JOAN OF ARC: HER IMAGE IN FRANCE AND AMERICA

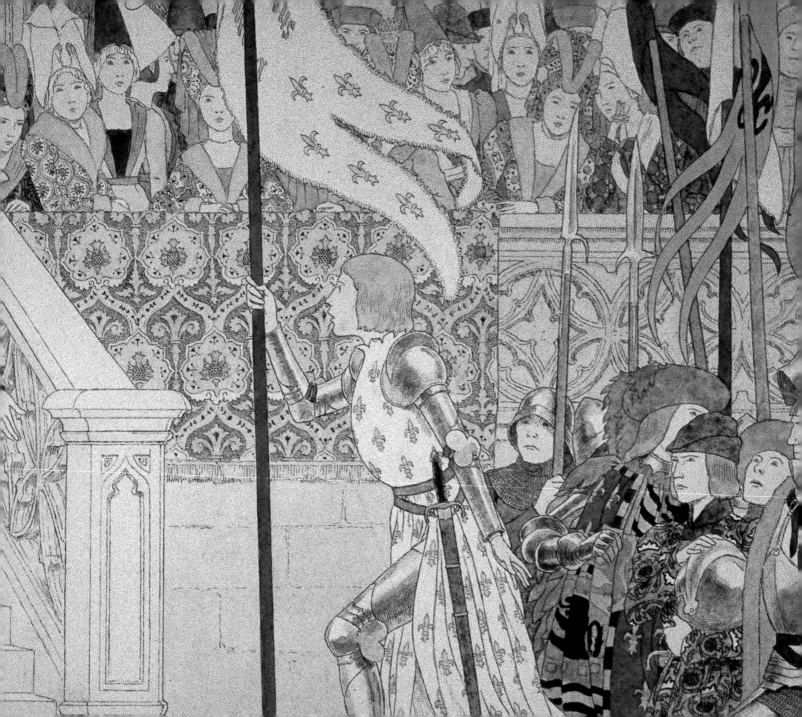

# JOAN OF ARC: HER IMAGE IN FRANCE AND AMERICA

Nora M. Heimann and Laura Coyle

Corcoran Gallery of Art, Washington, DC, in association with D Giles Limited, London

Jeanne d'Arc does not belong to France
alone, but also to all those whose
thoughts are elevated enough to grasp
the superior and the beautiful among
goodness.
*Louis-Maurice Boutet de Monvel,* 1913

We know what she was like, without
asking—merely by what she did....
She is easily and by far the most
extraordinary person the human race
has ever produced.
*Mark Twain,* 1904

# CONTENTS

# INTRODUCTION

With this publication the Corcoran Gallery of Art celebrates the legacy of the French medieval heroine Joan of Arc (ca. 1412-1431). Her extraordinary passage–from provincial peasant girl, to victorious army commander, to condemned martyr before she was twenty–has over the centuries inspired awe and admiration around the world. As one of the best known and most fascinating figures of the Middle Ages, she has attracted over the centuries legions of writers and artists.

Louis-Maurice Boutet de Monvel's *Joan of Arc* sextet (1906–ca. 1913; see figs. 1-6) at the Corcoran reigns as one of the most striking representations of the Maid's story. Now close to a century old, these paintings remain among the most successful in conveying to a diverse modern audience Joan of Arc's story and her image as a courageous, resolute girl.

Curiosity about these paintings led Laura Coyle, Curator of European Art at the Corcoran Gallery of Art, and Nora M. Heimann, Associate Professor of Art History at the Catholic University of America, to organize an exhibition and write this companion publication. The show and this book explore the history and meaning of Joan of Arc's image in French and American culture and thereby place Boutet de Monvel's Joan of Arc paintings into a social and historical context.

In the course of their research, many curators, historians, librarians, archivists, and others charged with preserving Joan of Arc's cultural legacy graciously assisted the authors. In France, they would like to express their profound gratitude to Olivier Bouzy at the Centre Jeanne d'Arc in Orleans, for sharing his time and expertise. Others from Joan's homeland provided assistance of various kinds and deserve their thanks, including: Chantal Bouchon, Marie-Claude Coudert, Marie-Odile Guy, Caroline Mathieu, Laurent Salomé, Anne Pingeot, and Evelyne Possémé. In the United States, Marianne Hansen at Bryn Mawr College Library; Mary Beth Dunhouse, Earle Havens, Dawn Bovasso, and Thomas Blake at the Boston Public Library; Daniel de Simone and Tambra L. Johnson at the Library of Congress; Jennifer Lee at Columbia University; and Lawrence R. Poos at the Catholic University of America were particularly helpful. Also to be recognized are: Charles Bennett, Susan Brown, Lisa Cain, Chan Chao, Lucy Commoner, Roger Diederen, Deborah Fraioli, Angela Gilchrist, George R. Goldner, Margaret Grasselli, Susan Halpert, June Hargrove, Carolyn and Tim Halpin-Healy, Jeanne

M. Heimann, Barbara Hinde, Carol Johnson, Donald LaRocca, Robert MacPherson, Mathilda McQuaid, Elena G. Millie, James Mundy, Nancy Norwood, Stuart Phyrr, Bonnie Salt, Karen Schneider, Perrin Stein, Christa Thurman, Gary Tinterow, Peter Trippi, Neal Turtell, Deborah Walk, Dennis Weller, Lawrence Wheeler, Eric White, Fredric W. Wilson, and Georgianna Ziegler.

At the Corcoran Gallery of Art, thanks go to former Director of the Corcoran, David C. Levy; our new Director Designate, Paul Greenhalgh; and Chairman of the Board, Jeanne Ruesch, for their leadership and support. Others at the Corcoran who enthusiastically pitched in at various stages include: Hilary Allard, Terri Anderson, Ken Ashton, Susan Badder, Molly Balikov, Marisa Bourgoin, Liz Bradley, Chris Brooks, Steve Brown, David Dorsey, Nicole Maria Evans, Abby Frankson, Katherine Gibney, Maria Habib, Dare Hartwell, Cory Hixson, Erin Johnson, David Jung, Jung-Sil Lee, Sarah Loffman, Camille Mathieu, Deborah Mueller, Kelli Park, Elizabeth Parr, Clyde Paton, Sarah Poitevent, Adam Robinson, Andrea Romeo, Ellen Root, Courtney Ruch, Leslie Schaffer, Schulyer Smith, Sian Sutcliffe, Nancy Swallow, Robert Villaflor, and Veronica Wolf.

The Corcoran thanks the Katherine Dulin Folger Publication Fund, the Samuel H. Kress Foundation, and The Andrew W. Mellon Research and Publications Fund for their generous support of this publication. Dan Giles, our publisher with nerves of steel, deserves our gratitude for his commitment to this project. Others who assisted at D Giles Limited include the production director, Sarah McLaughlin, designer, Misha Anikst, and copy-editor, David Rose. We also want to recognize the Knights of Columbus, especially Supreme Knight Carl A. Anderson, and anonymous individual donors who made possible the related exhibition, *Joan of Arc*, November 18, 2006–January 21, 2007. Last, but never least, the authors would like to thank the troupers at home for their constant encouragement, considered opinions, and infinite patience: John Emad Arbab, Douglas Dayton Robertson, and Mariana Virginia Coyle Robertson.

Jacquelyn Days Serwer
Chief Curator
Corcoran Gallery of Art
February 20, 2006

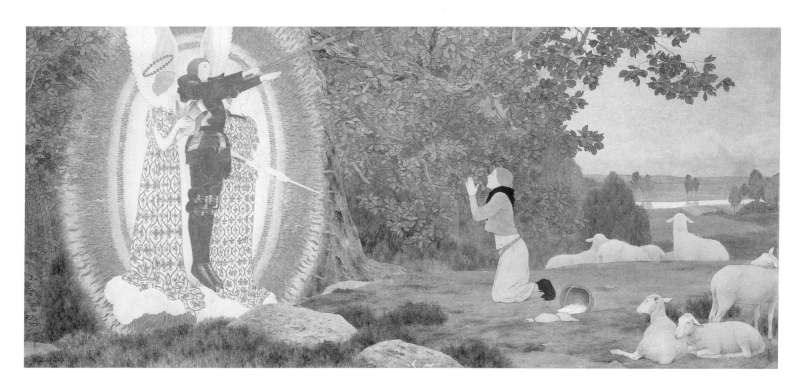

1
Louis-Maurice Boutet de
Monvel, *The Vision and
Inspiration,* ca. 1907–early
1909. Oil and gold leaf on
canvas. Corcoran Gallery
of Art, Washington,
DC. William A. Clark
Collection [26.141].

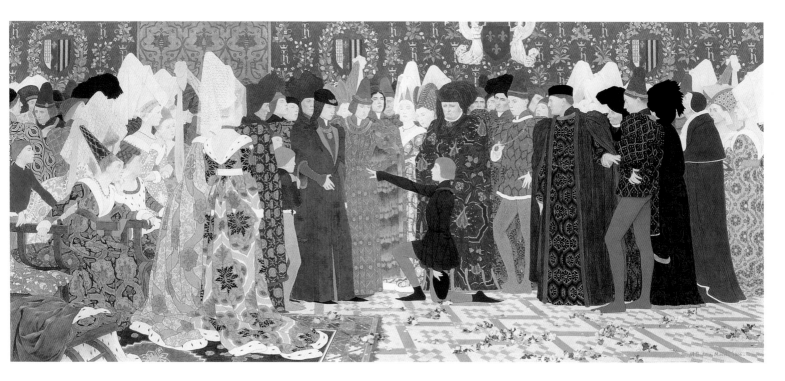

2

Louis-Maurice Boutet de
Monvel, *Her Appeal to
the Dauphin*, 1906. Oil
and gold leaf on canvas.
Corcoran Gallery of Art,
Washington, DC. William
A. Clark Collection
[26.142].

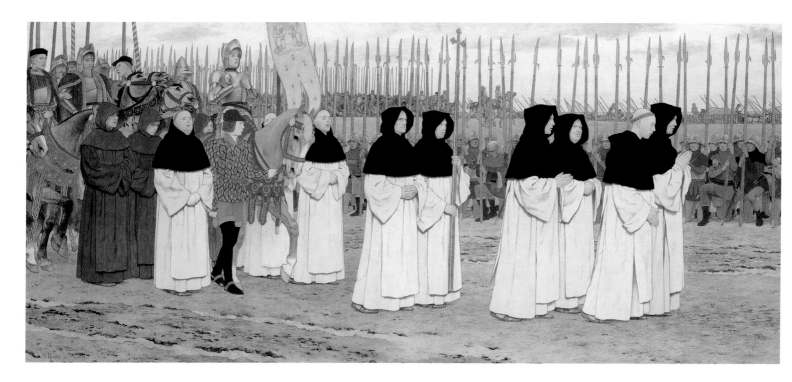

3
Louis-Maurice Boutet de
Monvel, *On Horseback,
The Maid in Armor*, ca.
1908–late 1909. Oil and
gold leaf on canvas.
Corcoran Gallery of Art,
Washington, DC. William
A. Clark Collection
[26.143].

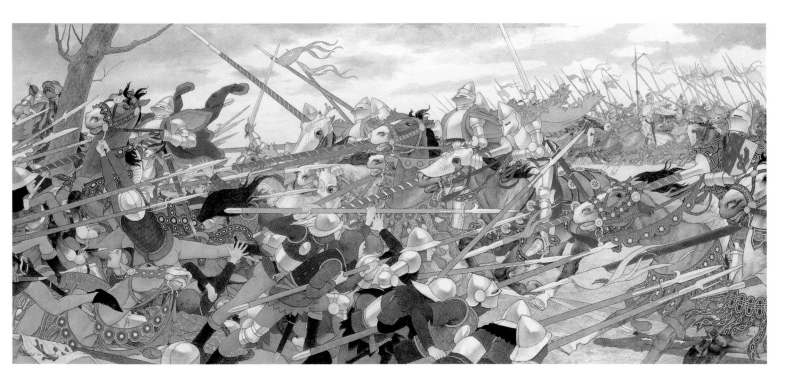

4
Louis-Maurice Boutet de
Monvel, *The Turmoil of
Conflict*, ca. late 1909-early
1913. Oil and gold leaf on
canvas. Corcoran Gallery of
Art, Washington, DC. William
A. Clark Collection [26.144].

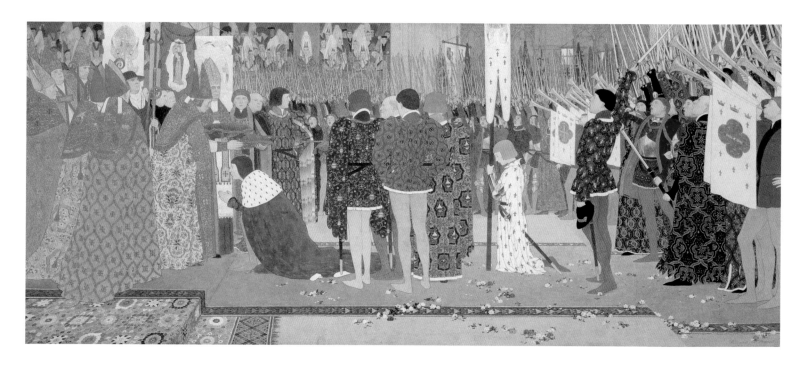

5
Louis-Maurice Boutet de
Monvel, *The Crowning at
Rheims of the Dauphin*,
1907. Oil and gold leaf on
canvas. Corcoran Gallery
of Art, Washington,
DC. William A. Clark
Collection [26.145].

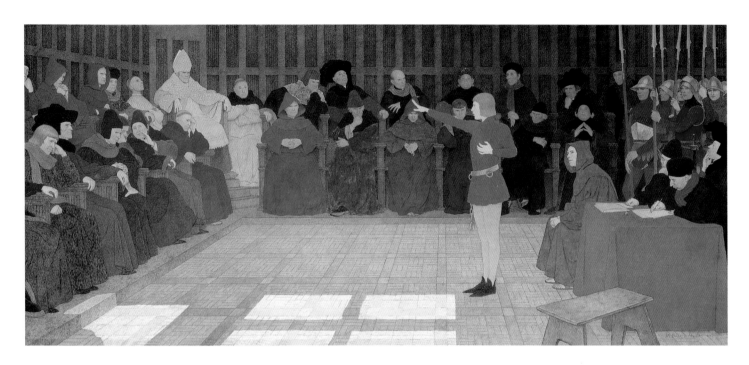

6
Louis-Maurice Boutet
de Monvel, *The Trial*, ca.
late 1909–early 1910. Oil
and gold leaf on canvas.
Corcoran Gallery of Art,
Washington, DC. William
A. Clark Collection
[26.146].

# JEANNE D'ARC

PAR

## M. BOUTET DE MONVEL

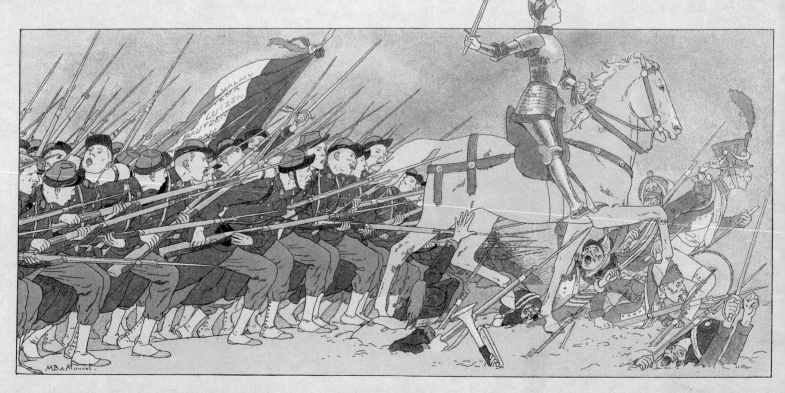

E. PLON, NOURRIT & Cⁱᵉ, IMPRIMEURS-ÉDITEURS, 10, RUE GARANCIÈRE, PARIS

# JOAN OF ARC: FROM MEDIEVAL MAIDEN TO MODERN SAINT

Nora M. Heimann
*Associate Professor of Art*
*The Catholic University of America*

Joan of Arc's brief but remarkable life lasted little more than two decades, of which only three years were spent on the world stage. No eyewitness images of her survive from her lifetime; and after her death at the stake in 1431, her remains were scattered in the Seine. Yet while Joan of Arc's actual appearance and physical remains have been lost to time, her vibrant memory has lived on to inspire literally thousands of artists and authors in her native France and beyond. This essay will chart the rise and transformation of this historic figure from her own day through the early twentieth century, when her popularity peaked on both sides of the Atlantic, culminating with her canonization by the Roman Catholic Church in 1920. At the heart of this project lies a collection of images of Joan of Arc's life produced by the *fin de siècle* French artist Louis-Maurice Boutet de Monvel, author and illustrator of *Jeanne d'Arc* (published in France from 1896 to 1981), one of the most enduringly popular biographies of Joan of Arc's life ever written (fig. 7). In addition to this beloved text, Boutet de Monvel also completed two cycles of paintings on the Maid's life—thirty-eight watercolors from 1896 (fig. 8), and six large canvases rendered in oil and gold leaf between 1906 and ca. 1912–13 (figs. 1-6). Together these masterworks illustrate the life of Joan of Arc in vividly compelling and meticulously rendered detail.

Although they were produced in France, many of Boutet de Monvel's most important images of Joan of Arc now take pride of place in America. His complete suite of Joan of Arc watercolors, first exhibited in the United States in 1899, was purchased from the artist's wife in 1920 for the Memorial Art Gallery in Rochester, New York, and his cycle of six paintings on the Maid's life, commissioned by the American collector William A. Clark, was bequeathed in 1925 to the Corcoran Gallery of Art in Washington, DC. Last, but not least, his lavishly illustrated book on the Maid was released in a dozen separate publications in America between 1896 and 1980.[1] In tracing the representation of Joan of Arc in the vibrant images of Boutet de Monvel, and in the most seminal likenesses of the Maid that were produced over the five

7
Louis-Maurice Boutet de Monvel, title page of the deluxe edition of his *Jeanne d'Arc*, no. 77 (Paris, 1896). Corcoran Gallery of Art, Washington, DC. Gift of an anonymous donor [2002.14]. (Photo: Chan Chao)

centuries that separated the life and work of this prominent artist from that of his most celebrated subject (figs. 3, 7, 9-11), this study seeks to illustrate the circumstances that were informed and transformed by the memory of this remarkable medieval maiden in France and America.

Joan of Arc was born in a country that was divided against itself and at war with England. That war—commonly known as the "Hundred Years War" (1337–1453)—began badly for the French with the destruction of their fleet in 1340. French defeats in 1346 and 1356 were compounded by the loss of Calais, the devastating impact of the Black Death, and the capture of the Valois king, John the Good. In the absence of the king, local French estates pressed for reform and increasing autonomy. In the process, what began as a dynastic feud between England and France became a civil war, especially after the onerous payment of the king's ransom ceded almost one third of France's territories to England. By 1407, war with England became almost a side issue in the fight between the Burgundians and the Armagnacs, as those loyal to Charles VI and his brother—the grandsons of John the Good—became known.

In 1415, about three years after Joan of Arc was born, Henry V of England landed with his troops at Harfleur to claim the throne of France, then held by Charles VI.[2] The subsequent defeats of the French at Agincourt, Caen, and Rouen led the Burgundians to enter an alliance with England in 1419 that, in turn, led Charles VI to sue for peace in 1420. In the

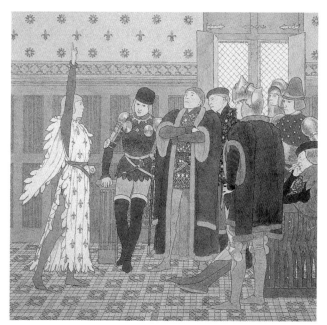

ensuing Treaty of Troyes, the French king surrendered his daughter Catherine's hand in marriage to Henry V, naming the British monarch heir apparent to the throne of France, and thereby disinheriting his own son, Charles the dauphin. The disinherited prince royal set up a satellite court in the unoccupied territories south of the Loire, while his sister Catherine sailed for England. She bore Henry a child in 1422. With the untimely death of Henry V nine months later, this infant was declared Henry VI, King of France and England.

It was to Charles, the dauphin in exile in Chinon (fig. 12), that Joan of Arc went in February 1429,

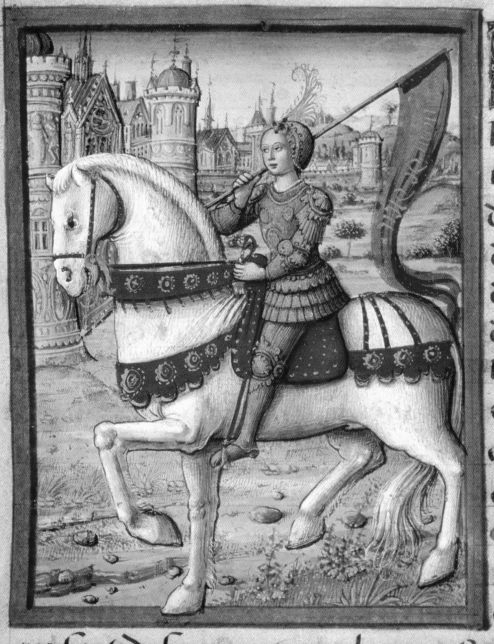

Ehanne surno
mee de waucou
leur natifue de lorrai
ne de ligne plebeicq
de nourriture rurale
de son estat bergiere
de cueur gentil petite
de stature: brefue en
langage substanci
euse en sentence legi
ere: agile sage deuote
et chaste hardie ma
gnanime et croy son
fait estre plus diuin
que humain. Car

au fait de sa vacation champestre: ou sinete chastioit
et to[us] honnestes fait se exercitoit lan mil iiiɉ xlȝ

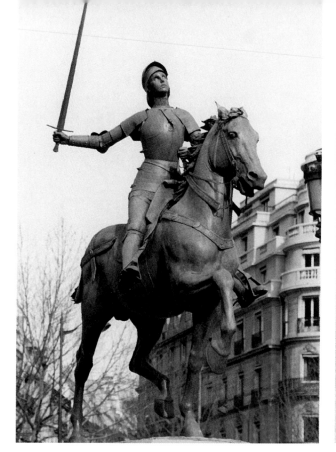

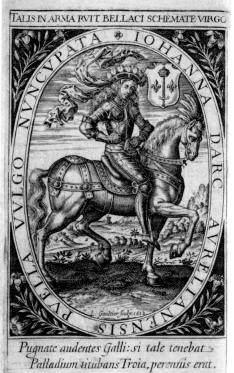

TALIS IN ARMA RVIT BELLACI SCHEMATE VIRGO

PVELLA VVLGO NVNCVPATA IOHANNA DARC AVRELIANENSIS

*L. Gaultier sculp. 1612*

*Pugnate audentes Galli: si tale tenebat*
*Palladium titubans Troia, perennis erat.*

bearing the news that God had spoken to her through his saints Michael, Catherine, and Margaret, telling her to wage war against the English. Joan later recounted that these angelic voices first began speaking to her when she was about thirteen years old (fig. 14). At that time, she was living with her parents, Jacques d'Arc and Isabelle Romée, in the tiny village of Domremy on the eastern frontier of France (fig. 13). Her saints commanded the young illiterate village girl to deliver France from its enemies by raising the siege of Orleans (a strategic stronghold on the Loire River besieged by the English since 1428), leading the dauphin to Rheims for his coronation, and driving the English from France. In the face of her reluctance, the saints reassured Joan, telling her to have "no doubts," for "God will give the victory."[3]

When Joan left the nearby fortified town of Vaucouleurs for Chinon accompanied by an escort of men given to her by Robert de Baudricourt

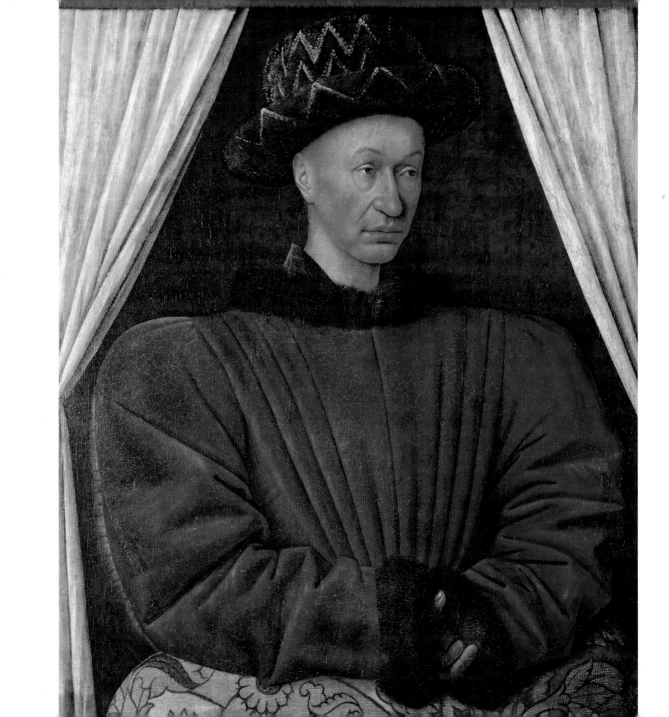

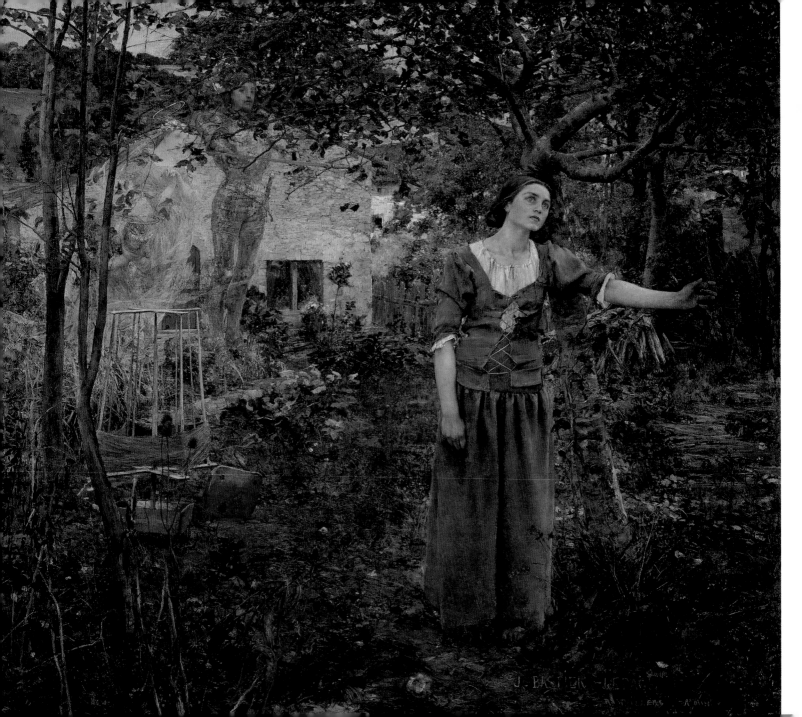

(a provincial nobleman loyal to the dauphin), she had already adopted male clothing and cut her hair short in the manner of a fashionable young man (fig. 15). Until the mid-nineteenth century, most images of Joan's journey to Chinon do not show her unusual masculine appearance at the start of her mission. Anonymous illustrators for early manuscript editions of Martial d'Auvergne's epic poem *Les Vigiles du roi Charles VII* (The Vigils of King Charles VII) (1477–84), for example, portrayed the Maid in a fitted gown and, at times, a shoulder-length veil secured by a cap (fig. 16). This demure costume reflected the understated style of women's dress that was popular around the time Martial d'Auvergne's poem was written, decades after Joan of Arc's death. The tendency to depict Joan of Arc in a modest feminine costume (usually stylishly anachronistic)—rather

16
Anonymous, *Joan of Arc at Chinon on her Way to Charles VII*, illuminated manuscript page in Martial d'Auvergne, *The Vigils of King Charles VII*, 1484. Bibliothèque Nationale, Paris [ms. fr. 5054]. (Photo courtesy Bildarchiv Preussischer Kulturbesitz /Art Resource, NY)

17
Gillot Saint-Evre, *Joan of Arc Kneeling before the Dauphin*, n.d. Oil on board. Collection Stair Sainty Matthiesen Inc., London.

than in the cross-dressed guise contemporary accounts indicate she adopted in 1429 and retained until her death—will mark portrayals of the Maid for over four centuries. As late as the 1830s, artists continued to portray Joan after the start of her mission in women's attire rather than in men's clothing, as can be seen illustrated, for example, by such early nineteenth-century paintings as Gillot Saint-Evre's oil sketch of *Joan of Arc Kneeling before the Dauphin* in a long grey dress and matching veil (fig. 17), and Paul Delaroche's celebrated painting of the Maid in prison in a low-cut brown dress and white fichu from 1824 (fig. 18).

Prior to the rise of modern historiography in the 1800s, which emphasized archival research and more ostensibly objective approaches to historical representation, artists and illustrators seldom depicted Joan of Arc in a manner that accorded with

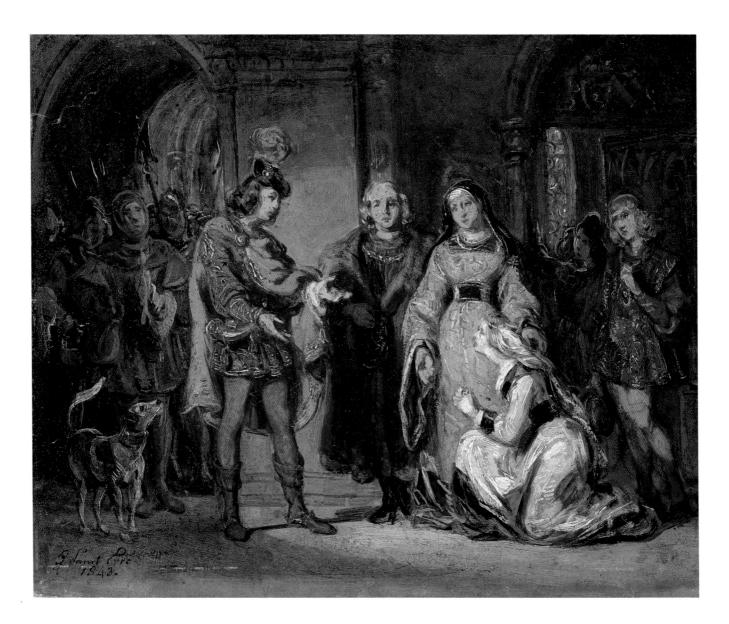

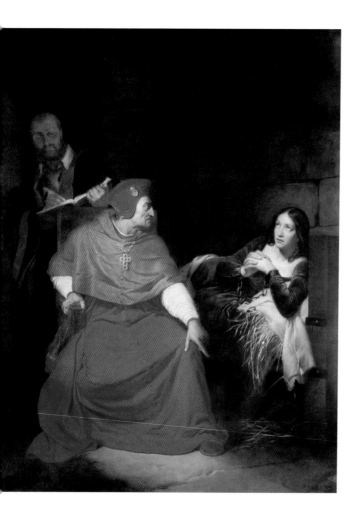

contemporary accounts of her appearance. Thus unlike Boutet de Monvel's vibrant (inventively colored and patterned, but otherwise accurately costumed) portrayal of Joan kneeling before the dauphin (see fig. 2 above), few prints or paintings before the mid-nineteenth century show Joan of Arc's bold arrival in Chinon clad in a man's suit and hose with arms, armor, horses, and a retinue, preferring instead to render her as a humble maiden.

According to contemporary witnesses, when Joan of Arc entered the court at Chinon, Charles hid among his attendants to test whether or not this provincial girl could discern him from the rest. Her voices, she later said, led her to recognize the dauphin. This was taken as proof of Joan's inspiration by Charles, as was the secret—still unknown—that she revealed to him as a sign conveyed to her by her voices. Cross-examined by the prince's retinue, and investigated again by members of the French Parliament then in exile in Poitiers, the Maid's story was tested and retested, as was her claim to virginity, which she asserted she had devoted to the service of God and his divine task in France. In April, having passed these tests of virtue and piety, Joan was finally granted the men and military equipment needed to march on Orleans.

Triumphing in a series of hard-fought battles, Joan and her soldiers won their first great strategic victory in lifting the siege of Orleans on May 8, 1429 (fig. 19, see also fig. 82 below). This swift success was seen by French royalists as a miracle. It confirmed

18
Paul Delaroche, *Joan of Arc, Sick, Interrogated in Prison by the Cardinal of Winchester*, exhibited Salon of 1824. Oil on canvas. Musée des Beaux-Arts, Rouen, France. (Photo: Erich Lessing. Photo courtesy Réunion des Musées Nationaux / Art Resource, NY)

19
Louis-Maurice Boutet de Monvel, *Attack on the Fortress of Les Tournelles*, from the deluxe edition of his *Jeanne d'Arc*, no. 77 (Paris, 1896). Corcoran Gallery of Art, Washington, DC. Gift of an anonymous donor [2002.14]. (Photo: Chan Chao)

20
Louis-Maurice Boutet de Monvel, *Joan before the Dauphin*, 1896. Watercolor. Memorial Art Gallery of the University of Rochester. Gift of Mr. Simon N. Stein.

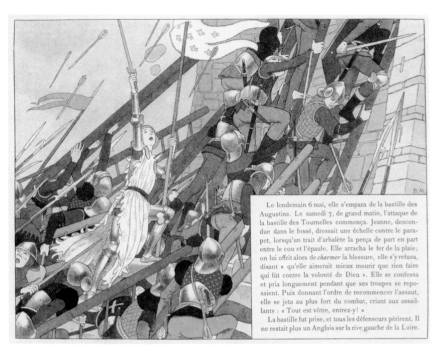

Le lendemain 6 mai, elle s'empara de la bastille des Augustins. Le samedi 7, de grand matin, l'attaque de la bastille des Tournelles commença. Jeanne, descendue dans le fossé, dressait une échelle contre le parapet, lorsqu'un trait d'arbalète la perça de part en part entre le cou et l'épaule. Elle arracha le fer de la plaie; on lui offrit alors de *charmer* la blessure, elle s'y refusa, disant « qu'elle aimerait mieux mourir que rien faire qui fût contre la volonté de Dieu ». Elle se confessa et pria longuement pendant que ses troupes se reposaient. Puis donnant l'ordre de recommencer l'assaut, elle se jeta au plus fort du combat, criant aux assaillants : « Tout est vôtre, entrez-y! »

La bastille fut prise, et tous les défenseurs périrent. Il ne restait plus un Anglais sur la rive gauche de la Loire.

Joan's divine mission, and won her the popular name "*la Pucelle d'Orléans*" (the Maid of Orleans), an honorific by which she is still known. By late June, Joan convinced Charles to travel with her through enemy territory to Rheims, predicting that the great danger this venture entailed would be worth the prize (fig. 20). This political gamble paid off on July 17, 1429, with the dauphin's coronation as Charles VII in a sacred rite that conveyed the ineluctable mark of divine legitimacy to the Valois cause (see fig. 5 above). While the newly crowned king withdrew from battle, Joan pressed on with her soldiers, leading them by August to the very gates of Paris.

In early September 1429, however, the fortunes of the Maid began to turn when her soldiers' assault to the north of Paris failed. This demoralizing failure, in which Joan herself was wounded, was followed by the king's command that the army disband. After a difficult winter of inactivity punctuated by a series of unsuccessful skirmishes, Joan was captured in the spring by her Burgundian foes. Refused ransom by the Valois in 1430, she was sold to the British. Within a year, following a lengthy trial conducted by over

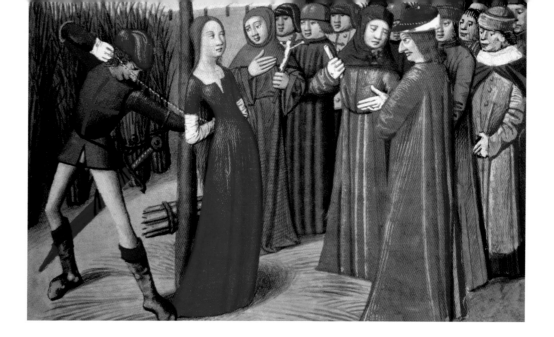

21

Anonymous, *Execution of Joan of Arc*, illuminated manuscript page in Martial d'Auvergne, *The Vigils of King Charles VII*, 1484. Bibliothèque Nationale, Paris [ms. fr. 5054, folio 71]. (Photo courtesy Bridgeman-Giraudon /Art Resource, NY)

22

Anonymous, *The Trial of Joan of Arc*, manuscript illumination, mid-15th century. Bibliothèque Nationale, Paris [ms. lat. 5969, p. 1]. (Photo courtesy Snark / Art Resource, NY)

23

Clément de Fauquembergue, [Joan of Arc], drawn in the margin of the register of the Parliament of Paris, 1429. Archives Nationales, Paris [inv. AE II, 447]. (Photo: Bulloz. Photo courtesy Réunion des Musées Nationaux / Art Resource, NY)

one hundred theologians, clerics, and legal scholars from the University of Paris, the Maid was condemned as a heretic (see fig. 6 above). On May 28, 1431, she was handed over to the secular authorities for punishment. Two days later, she was burned at the stake in the Old Market Place in Rouen (fig. 21). Witnesses to her death later recounted that her remains were reduced to ashes and thrown into the Seine to prevent the taking of relics, but that her heart—which was also thrown into the river— remained miraculously uninjured and intact.

The original transcripts of the Maid's first trial from January to May 1431, and her second (nullification) trial 25 years later (convened by papal authority from 1455–56 to reconsider her conviction of heresy), both survive. These massive tomes combine word-for-word transcriptions of the Maid's voice, and the testimony of literally hundreds of friends, family members, fellow men-at-arms, priests, confessors, and other close associates (fig. 22). Together, they give us a remarkable record of one woman's life. Indeed, they render Joan of Arc one of the best documented individuals from medieval history.[4]

What we do *not* know from these records, however, is how Joan of Arc looked, aside from what she wore and that she cut her hair short, for no contemporary eyewitness portraits of her survive. The one contemporaneous image of her preserved from 1429 was, with certainty, drawn by the hand of someone who never saw Joan in person (fig. 23). Sketched by the Burgundian scribe Clément de Fauquembergue in the margins of the register of the Parliament of Paris beside the official announce-

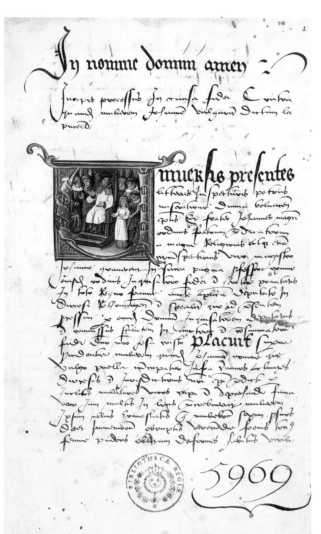

ment of the defeat of the English at Orleans, this drawing—it's more a doodle really—of the Maid is no more accurate in its three-quarter length profile portrayal of her with abundant long wavy hair in a scoop-necked dress with ample decolletage than it is unbiased in its conception. Shown holding the hilt of a sword with her left hand and a standard with her right, Joan's fierce expression and buxom figure may have been intended to portray her — the young woman known derisively by the Anglo-Burgundians as "the Harlot of the Armagnacs"—as an immodest shrew. If so, the Burgundian scribe's decision to depict Joan with exaggerated feminine qualities and a scowl may have been motivated by a partisan spirit not unlike that which later moved William Shakespeare to depict Joan in his anglo-centric play *Henry VI, Part I* as a promiscuous liar and a witch.  Under Shakespeare's pen, "Joan the Pucelle" (Joan the Maid) becomes an evil conniver, who opportunistically feigns virtue while actually deriving her victories in battle with the aid of fiends and demons.  This pejorative personification was presumably intended to cast doubt on the Maid's military accomplishments against the English and their Burgundian allies (fig. 24).

After her death, as during her life, Joan of Arc became the object of both mordant condemnation and exultant admiration. Joan's partisan political following in her own day was matched in the literary realm, as many of her earliest authors contested or celebrated her role in history with commensurate praise or censure, depending on their

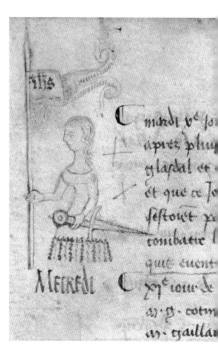

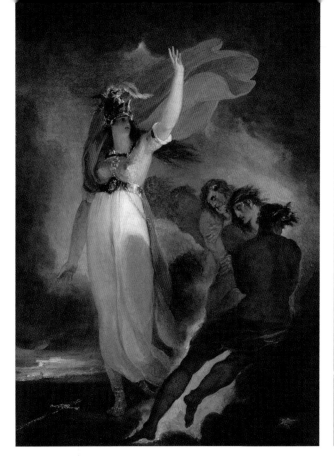

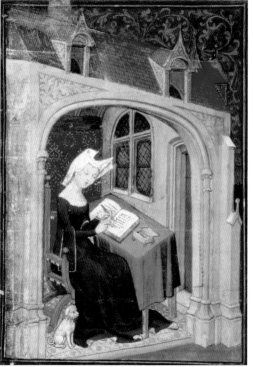

24
William Hamilton, *Joan and the Furies*, 1795. Oil on canvas. France Lehman Loeb Art Center, Vassar College Art Gallery, Poughkeepsie, NY. Purchase, Betsy Mudge Wilson, Class of 1956, Memorial Fund [1966.12].

25
Master of the Cité des Dames, *Christine de Pizan Writing at her Desk*, manuscript illumination from the *Works of Christine de Pizan*, ca. 1412–15. British Library, London [Harley MS 4431, fol. 4]. (Photo courtesy Art Resource, NY)

26
Anonymous, *Joan Compared to Judith*, manuscript illumination from Martin le Franc's *The Champion of Women*, ca. 1451. Bibliothèque Nationale, Paris [ms. fr. 12476]. (Photo courtesy the Centre Jeanne d'Arc, Orleans)

Burgundian or royalist sympathies. Among Joan's earliest and most eloquent admirers was Christine de Pizan, a fifteenth-century Italian scholar living in France, who was closely associated with the court of Charles VII (fig. 25). When the Burgundians captured Paris from the Armagnacs in 1418, Pizan was forced to flee her home, which may explain the strong personal sentiment that seems to suffuse her famous sixty-one stanza poem on the Maid, *Le Ditié de Jehanne d'Arc*, the first major literary work to honor Joan of Arc.[5] Composed on July 31, 1429, Pizan's homage begins jubilantly, rejoicing at the King's divinely providential coronation less than two weeks earlier. Exalting that this triumph was made possible by the remarkable heroism of a woman who was blessed by God and foretold by the oracles of old, the poet declares Joan "an honor for the feminine sex!," equal to the greatest Old Testament heroes and heroines. Likening the Maid to Moses in her ability to deliver "God's people," to

Joshua in her bravery and capacity to conquer "where so many met defeat," and to Esther, Judith, and Deborah as "valiant" and "courageous ladies... through whom God worked his miracles," Pizan boldly asserts her young heroine's supremacy over even the most legendary of mortal heroes, Hector and Achilles.[6]

Among the many fifteenth- and sixteenth-century authors and artists who followed in Pizan's wake by similarly employing exemplary precedent to support the righteousness of the Maid's mission was an anonymous illustrator for *Le Champion des dames* (The Champion of Women), a five-volume poetic dialogue in praise of women composed soon after Joan's death by the papal secretary Martin Le Franc. Penned in response to Jean de Meung's *Le Roman de la rose* (The Romance of the Rose), an enduringly popular and highly misogynistic allegory from the thirteenth century, Le Franc's remarkable proto-feminist poem included thirty-two stanzas devoted to defending Joan of Arc against her mortal condemnation for cross-dressing, belligerence, and heresy.[7] Arguably, the most celebrated illustration for this text is the miniature illumination of Joan as Judith in a manuscript now in the Bibliothèque Nationale, Paris (fig. 26). In this memorable image, "Joan the Maid" is shown in armor, with spear and shield in hand, looking on while "Dame Judith" stands beside the tent of Holofernes, smiling jubilantly with her bloody sword raised, as she lowers her enemy's severed head into a waiting sack held by her maidservant.

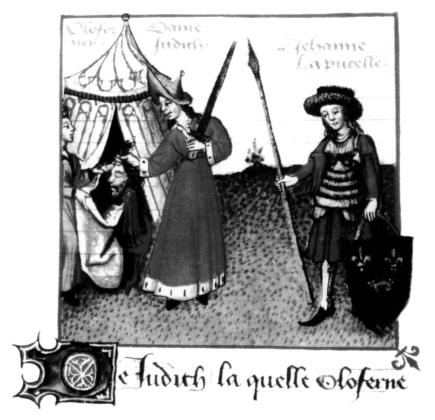

Despite the express prohibition against transvestism in the Old Testament and in contemporary church teachings, Le Franc upheld Joan of Arc's right to wear men's clothing by arguing that many ancient biblical laws had long been abandoned by faithful Christians, and by insisting further that Joan's dress was both sensible and necessary for a leader of men in battle. His strong support for the

Maid's cross-dressing was not shared by most
early modern authors and artists, even those sym-
pathetic to Joan's cause. For example, Jean Hordal,
a descendant of Joan of Arc's brother Pierre and a
professor at the University of Pont-à-Mousson,
illustrated his highly influential *Heroinae
Nobilissimae Joannae Darc Lotharingae Vulgo
Aurelianensis Puellae Historia* (History of the Most
Noble Heroine Joan of Arc Virgin of Lorraine)
(Pont-à-Mousson, 1612) with three engraved por-
traits by Léonard Gaultier that together work to
minimize the Maid's rejection of sartorial norms.
The illustration on the top of the title page, derived
from the first monument to the Maid erected in
1502 on the bridge of Orleans, shows Joan piously
kneeling with Charles VII before a scene of the pietà
wearing a suit of armor with the clearly feminine,
maidenly attribute of long unbound hair (fig. 27).
The second, on the verso of page 2, shows Joan
astride a galloping warhorse, again wearing a full

suit of armor with long loose hair, now topped by a hat with a banded brim covered with large white plumes; above this equestrian scene, a caption in Latin reads "Thus in arms the virgin rushed forth in warlike form" (see fig. 11 above). This plate is twinned, on the license to print page, by a three-quarter length portrait of the Maid wearing the same lavishly plumed hat with the same long loose hair, except now Joan is shown wearing a dress—tightly corseted with embroidered trim, a full skirt, and elaborate sleeves decoratively puffed and slashed at the shoulder and elbow. In this elegant, ladylike costume, Joan stands holding aloft an unsheathed sword in her right hand while clutching a handkerchief in her left (fig. 28). The caption to this image insists in Latin: "Thus when unarmed the Maid wore feminine dress."[8]

Gaultier's corseted and sword-brandishing heroine likens Joan of Arc to the same biblical prototype that both Christine de Pizan and Martin Le Franc evoked—Judith. Gaultier's Maid alludes to this Old Testament heroine in both stance and dress, which appear modeled on the many paintings of Judith as a courtly sixteenth-century woman warrior portrayed by the prominent German painter Lucas Cranach the Elder. Cranach the Elder rendered over a dozen *Judith*s, including a painting from the early 1530s now in Vienna (fig. 29), which portrays the biblical heroine clad in a corset dress and a plumed hat, with a sword clasped in her right hand and her enemy's severed head in her left. Cranach's distinctive portrayals of *Judith*

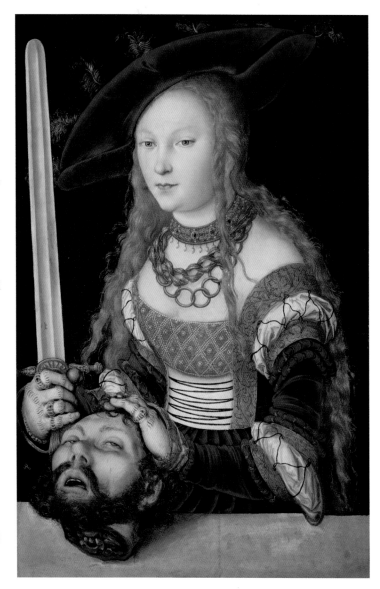

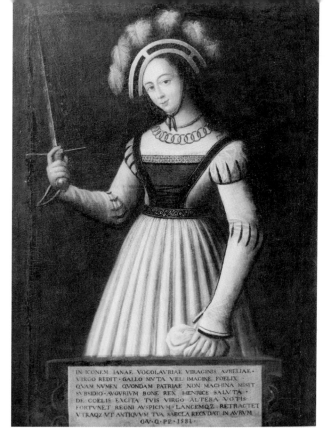

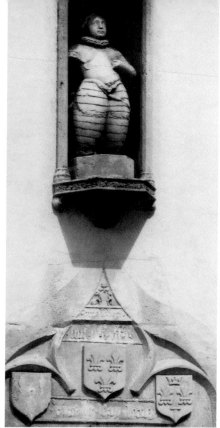

left their legacy not only in Gaultier's memorable engraving of the Maid, but also in an even more venerable rendering of Joan, now known as the *Portrait "des Échevins"* or *Aldermen Portrait* (ca. 1575–81), from Orleans (fig. 30). This iconic image, Joan of Arc's most copied early representation, may, in fact, have provided the visual link between Cranach's German *Judith* and Gaultier's French Maid, for the *Aldermen Portrait* appears to represent the first instance in which Cranach's courtly example was absorbed into the Maid's early imagery.[9]

Long believed, erroneously, to have been rendered from life on commission by the Aldermen of Orleans in gratitude for the lifting of the siege of their city, the *Aldermen Portrait*, with its fanciful costume, flamboyantly plumed hat, and raised sword, served as one of two early prototypes for images of the Maid. The other seminal prototype—of Joan of Arc kneeling in profile in a stout suit of armor with long, wavy unbound hair, as depicted in the first monument to the Maid in 1502—inspired far fewer images than the *Aldermen*

*Portrait* over time, possibly because the statue was partially destroyed in the 1560s by Calvinist iconoclasts (for a partial reconstruction of this image, see fig. 27 above).[10] In the first centuries after the Maid's death, however, this pious incarnation prompted a number of significant works, including a carved stone sculpture of the Maid kneeling with her hands clasped in prayer wearing a starched ruff and a suit of armor that was placed in a niche over the doorway to the historic d'Arc family home in Domremy in the late sixteenth century or early seventeenth (fig. 31). The most prominent image of this type is undoubtedly the *Joan of Arc* portrait attributed to Peter Paul Rubens and his workshop from around 1617 to 1620 (fig. 32). In the hands of this pre-eminent Flemish master and his followers, Joan of Arc adopts the same devotional posture as in her first monumental incarnation in bronze, only now, rendered in paint, she becomes a full-bodied, rosy-lipped beauty with long auburn hair partially braided at the nape of her neck and falling in waves down her back. Kneeling in profile before a crucifix mounted on a low stone pedestal, Joan appears as a martial persona, softened by her ardent devotion, ruddy complexion, and luxurious hair. The icy gunmetal grey of the Maid's armor is similarly tempered by the application of delicate gold detailing, and warmed by the painting's vibrant surroundings — a loosely sketched red and gold Turkish carpet in the foreground, and a broadly brushed crimson curtain that frames the left background, separating this intimate devotional scene

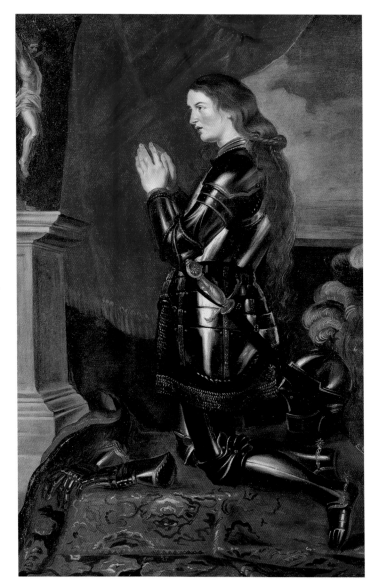

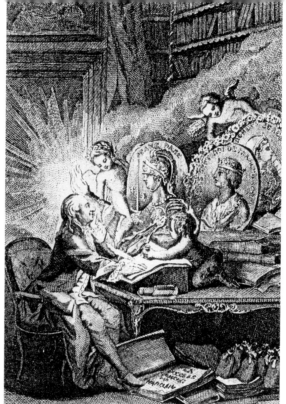

from the distant, cool, cloud-filled sky to the right.

Based on the work's uneven paint application, Rubens scholars have suggested that this *Joan of Arc* may be either a copy after a now-lost original, or an unfinished painting begun by the Flemish master that was completed by another, lesser hand.[11] There is no doubt, however, that this composition was based on Rubens's own conception, for a fully realized study for the work in the hand of Rubens survives in brown ink and black crayon on paper.[12] Moreover, the artist's enduring interest in the work's subject—inspired, perhaps, by a friend of

Rubens who penned a Latin poem in the Maid's honor—may be witnessed by the fact this portrait remained in the artist's personal collection at his death.[13] Thus although some uncertainty surrounds the authorship of portions of this painting, Rubens's *Joan of Arc* remains an intriguing image of a remarkable young woman as envisaged by one of the most important painters of the seventeenth century.

While the appearance of Joan of Arc kneeling in armor, derived from the first monument to the Maid, became relatively obscure by the mid-1600s, the image of Joan standing like Judith in a gown

JEANNE D'ARC.

Jeanne montra sous féminin visage,
Sous le corset et sous le cotillon,
D'un vrai Roland le vigoureux courage.

lived on in a multitude of art works from the late sixteenth century through the mid-nineteenth, as again and again the distinctive plumed hat, corset dress, slashed sleeves, and posture of the *Aldermen Portrait* was given form in every conceivable media: from a now lost portrait of Joan of Arc produced for Richelieu's Palais Cardinal, Paris, in 1635 (fig. 33), to illustrations inspired by Voltaire's eighteenth-century epic satire *La Pucelle d'Orléans* (The Maid of Orleans) (figs. 34, 35), to E.-É.-F. Gois's bronze *Joan of Arc in Battle* (figs. 36, 37), to Auguste Vinchon's monumental canvas of *The Coronation of Charles VII at Rheims* from 1838 (fig. 38). Versions of the *Aldermen* costume even appeared in nine-teenth-century history paintings that cast Joan of Arc in masculine attire. For example, in 1819,

36
Charles-Pierre-Joseph Normand, "Joan of Arc, Maid of Orleans," etching after Edme-Étienne-François Gois *fils*, from C.-P. Landon, *Annals of the Museum…*, vol. 3 (Paris, [1802]). (Photo courtesy the Centre Jeanne d'Arc, Orleans)

37
Edme-Étienne-François Gois *fils*, *Joan of Arc in Battle*, exhibited Salon of 1802, cast in bronze 1804. Rue des Tourelles, Orleans, France. (Photo: Nora M. Heimann)

Joan of Arc: From Medieval Maiden to Modern Saint

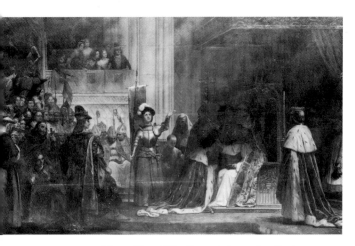

Pierre-Henri Révoil, a painter and collector from Lyon, who made his career by depicting scenes of medieval and Renaissance life with elaborate archaeological accuracy, portrayed the Maid in captivity wearing a medieval man's surcoat and hose in both an oil on canvas and a watercolor and ink rendering of *Joan of Arc as a Prisoner in Rouen*, adding to both of these paintings the incongruous additions of corseting, puffed and slashed sleeves, and a plumed beret *à la Aldermen* (figs. 39, 40). The mixture of meticulous historic detail and venerable anachronisms in these elaborate images of the Maid's unflinching courage before a host of hostile captors won the praise of the leading art critic Charles-Paul Landon, who saw Révoil's *Joan of Arc* as proof of the artist's "very distinguished talent," "intellect and taste," and "rare erudition."[14]

Among the countless works inspired by the

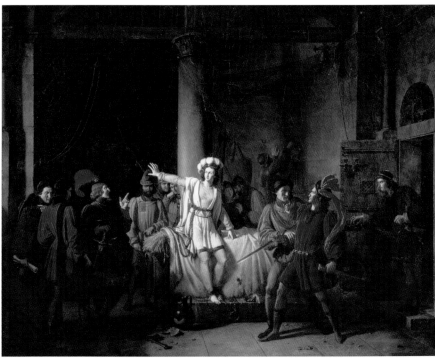

38
Auguste Vinchon, *The Coronation of Charles VII at Rheims (July 17, 1429)*, exhibited Salon of 1838. Oil on canvas. Châteaux de Versailles et de Trianon, Versailles, France. (Photo courtesy Réunion des Musées Nationaux / Art Resource, NY)

39
Pierre-Henri Révoil, *Joan of Arc as a Prisoner in Rouen*, exhibited Salon of 1819. Oil on canvas. Musée des Beaux-Art, Rouen, France. (Photo courtesy Bridgeman-Giraudon / Art Resource, NY)

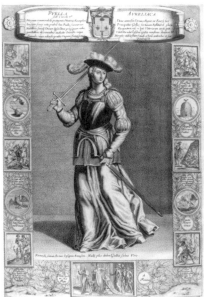

*Aldermen Portrait*, the seventeenth-century image of Joan of Arc painted for the Palais Cardinal was certainly one of the most celebrated. Completed around 1635 by Philippe de Champaigne or Simon Vouet, this canvas (destroyed in 1940, but recalled by numerous engravings) was one of a suite of paintings of twenty-two nationalist and noble French men and three women destined for Richelieu's new Gallery of Illustrious Men. Together, these portraits call upon the tradition that Christine de Pizan's poem also evoked of celebrating moral virtue by honoring a selected ensemble of the most worthy and illustrious men and women from history, legend, and the Bible. In so doing, this suite helped to establish the cardinal as one of the most distinguished patrons of his day, and his artists, Champaigne and Vouet, as two of the foremost painters in Paris.

The most ornate of the many prints made after Champaigne's (or Vouet's) painting of Joan for Richelieu is surely the engraving of *The Maid of Orleans* by Zacharie Heince and François Bignon for Marc Vulson de la Colombière's *Les portraits des hommes illustres françois: qui sont peints dans la galerie du Palais Cardinal de Richelieu...* (Portraits of Illustrious French Men, who are portrayed in the gallery of the Palace of Cardinal Richelieu...) of 1690 (fig. 41). In this engraving, the

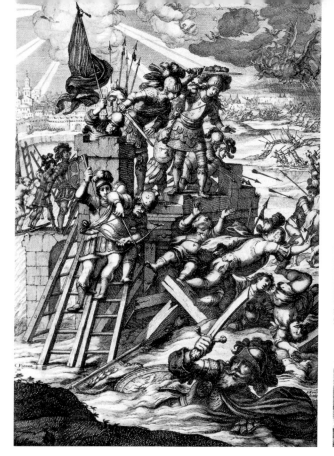

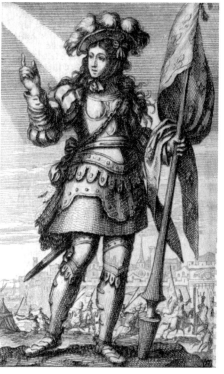

now operatic figure of Joan, wielding an epée in a long gown surmounted by a cuirasse and a coat of mail, appears decoratively framed by scenes from her life, beginning with the Maid's first encounter with the dauphin at the top left and ending with her death at the stake in the lower right. These motifs alternate with medallion-shaped emblems. The first emblem, a ball of yarn, likens Joan to Ariadne in leading her king out of a labyrinth; the last, a phoenix, symbolizes the ultimate triumph of Joan's cause, which like this legendary bird, rose from the ashes of her death. At the bottom, the inscription in Latin praises Joan in terms directly borrowed from Pizan's *Ditié*: "Honor to your Sex, Amazon famed for your arms"; while at the top, a Latin text again borrows from Pizan's poem in likening the Maid to Hercules, and in praising her accomplishments as a memorable example of God's divine protection.[15]

Around the same time that Richelieu's artists

were completing their painted homage to Joan of Arc for Richelieu, Jean Chapelain, one of the leading poets of the seventeenth century, began writing an epic poem on the life of Joan of Arc at the behest of the duc de Longueville, a descendant of Joan of Arc's companion-at-arms, the comte de Dunois. Thirty years later, in 1656, the first twelve cantos of this monumental effort were published in a sumptuous first edition embellished with thirteen folio-sized plates by Claude Vignon and Abraham Bosse (fig. 42). Vignon and Bosse may have been chosen for this task because they had already collaborated in producing an illustration of the Maid as one of a suite of twenty plates of heroic women for Pierre Le Moyne's successful *La gallerie des femmes fortes* (Gallery of Heroic Women) from 1647 (fig. 43).[16]

Modeled on Torquato Tasso's *Jerusalem Delivered* (1581) and Virgil's *Aeneid*, Chapelain's *La Pucelle ou la France delivrée, poëme héroïque* (The Maid, or the Heroic Poem of France Delivered) (Paris: Augustin Courbe, 1656), celebrated the liberation of Orleans, the restoration of the French throne, and the reunification of France. Long awaited by the author's literary followers, the work enjoyed an immediate, if ephemeral, success, as the first edition was reprinted five times in the following eighteen months. Deplored by the critics, however, Chapelain's grandiose and highly fictionalized poem, which flattered the poet's patron by focusing on the exploits of his ancestor Dunois more than the accomplishments of Joan of Arc, soon fell into disfavor; and the remaining twelve cantos of *The*

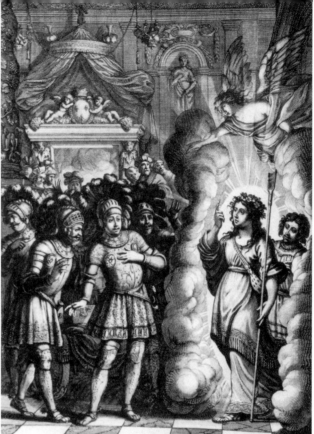

44
Claude Vignon, "Joan of Arc is Presented to the King," etching by Abraham Bosse, from Book 1 of Jean Chapelain, *The Maid, or the Heroic Poem of France Delivered* (Paris, 1656). (Photo courtesy the Centre Jeanne d'Arc, Orleans)

*Maid* (completed by 1670) remained unpublished for over two centuries. The illustrations for Chapelain's epic poem, however, enjoyed a more enduring success by inspiring a set of Aubusson tapestries depicting the Maid's life. Like the verses they embellished, Vignon's fanciful designs for Chapelain were grand and ahistorical. His illustration for Book 1 of Chapelain (fig. 44), for example, portrays Joan arriving in Chinon on a billowing cloud of light wearing the improbable costume of

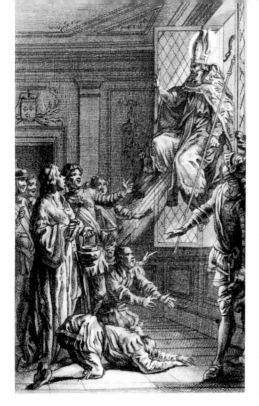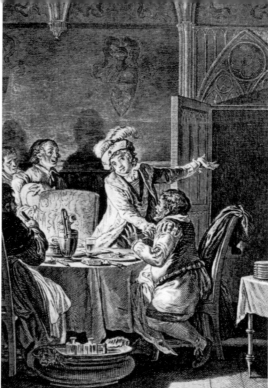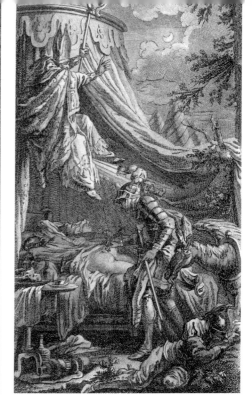

an ancient Roman shepherdess, complete with a staff, sandals, and a girdled tunic with a wreath of flowers in her hair. Her appearance, presumably designed to make the Maid appear at once classically heroic and provincially rustic, bears no resemblance to the short masculine haircut and men's clothing that Joan actually wore when she arrived at the Valois court in exile in the winter of 1429. In Vignon's scene of battle at Orleans (see fig. 42 above), the Maid again stands haloed by beams of light, now at the summit of a bulwark with her sword raised over her head, wearing a suit of plate and mail armor with sleeves puffed and slashed at the shoulder, and her long hair flying out from beneath a plumed helmet. This distinctive costume is—as before—anachronistic, now modeled both on the sixteenth-century *Aldermen Portrait* (see fig. 30 above), and on the seventeenth-century image of the Maid realized for Richelieu's gallery of illustrious individuals (see fig. 41 above).

While Chapelain's *The Maid* enjoyed only the most ephemeral literary success, it served to inspire one of the most influential poems ever written about the Maid of Orleans—the epic parody *La Pucelle d'Orléans* (The Maid of Orleans) by François-Marie Arouet, better known by his *nom de plume* Voltaire

(see fig. 34 above). According to legend, Voltaire penned this satire in response to a friend's challenge that he produce a better treatment of the Maid's life than Chapelain's ponderous poem. What resulted was a manuscript that became a scandalous success as it circulated throughout Europe without the author's permission in a series of pirated manuscript (and later clandestine print) editions, from the 1730s through the mid-1800s. Despite being banned and burned as profligate, Voltaire's *Maid of Orleans* proliferated in over 135 different editions, enduring as one of the most widely read texts on Joan of Arc for over a century after it was first released. In this process, the notoriety of Voltaire's ribald text catapulted a relatively minor medieval heroine onto the center stage of French history by inciting generations of outraged and intrigued authors and artists, politicians and prelates to respond to his Maid.

The satiric nature of Voltaire's mock epic is introduced in its opening scene. There, Saint Denis, as the patron saint of France, observes Paris in flames while its "very Christian King" dallies with his lover and does nothing. Pitying the people of his land, Saint Denis decides to intervene by sending a virgin "to save France and its honor."[17] The saint's only problem, the author notes dryly, is the scarcity of true maidens in France. Knowing that he would never find a woman of honor at court, the saint departs on a golden sunbeam to find in a cabaret the last remaining virgin in the land—Joan the Maid (fig. 45). During the poem's remaining cantos,

Voltaire recounts the saint's ongoing efforts to preserve Joan's chastity, as well as the intimate affairs of Charles, his mistress, and other courtly and ecclesiastical figures, whose indolent licentiousness is contrasted facetiously with the Maid's miraculous virginity. Highlighting the misbehavior of clerics and courtiers, Voltaire's poem parodies Chapelain's romantic epic at the same time that it mocks the corruption of the monarchy and the Catholic Church, which Voltaire believed were the root causes of injustice and intolerance.

The plentiful illustrations that accompanied the many authorized and unauthorized editions of Voltaire's text in the eighteenth century varied widely in quality, from crudely rendered and often plagiarized anonymous prints to beautifully etched and engraved plates by master illustrators such as Jean-Michel Moreau *le Jeune* (fig. 46). They also ranged widely in tone from patently pornographic portrayals to simply flirtatious representations, such as Gravelot's image (for the first authorized edition of Voltaire's poem in 1762) of the Maid proving her courage by entering the enemy camp and stealing the breeches of a slumbering English nobleman, after brazenly drawing three fleur-de-lys on his bare bottom (fig. 47).

Voltaire's satire inspired subsequent images of a sexy Maid, such as Charles-Étienne Gaucher's portrayal of a coy Joan in a tightly fitted bodice peering from below her feathered hat with a come-hither glance (see fig. 35 above). In this edition of Gaucher's print, a caption excerpted from Voltaire's

45
Gravelot [Henri-Hubert-François Bourguignon d'Anville], illustration for canto 1 in Don Apuleius Risorious, bénédictin [Voltaire], *The Maid of Orleans: Poem Divided into twenty cantos, with notes.* (Geneva, 1762). (Photo courtesy the Centre Jeanne d'Arc, Orleans)

46
Jean-Michel Moreau *le jeune*, illustration, engraving by Joseph de Longueil, for canto 12 in Voltaire, *The Maid, Poem, followed by the Tales and Satires of Voltaire* (Kehl, 1789). (Photo courtesy the Centre Jeanne d'Arc, Orleans)

47
Gravelot [Henri-Hubert-François Bourguignon d'Anville], illustration for canto 2 in Don Apuleius Risorious, bénédictin [Voltaire], *The Maid of Orleans: Poem Divided into twenty cantos, with notes.* (Geneva, 1762). (Photo courtesy the Centre Jeanne d'Arc, Orleans)

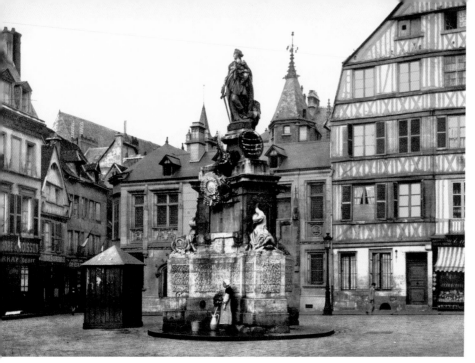

48
Paul Ambroise Slodtz,
*Joan of Arc as Bellona*,
place de la Pucelle, Rouen;
unveiled 1755, destroyed
by bombing June 2, 1944.
Photochrom, ca. 1890-1900,
Library of Congress, Prints
& Photographs Division,
Photochrom Collection.
(LC-DIG-ppmsc-05348)

49
Anonymous, "Joan as
Minerva," frontispiece
from Friedrich Schiller,
*Joan of Arc, or the Maid
of Orleans* (Paris, [1802]).
(Photo courtesy the Centre
Jeanne d'Arc, Orleans)

*Maid of Orleans* invites the viewer to take a mental peep up the Maid's skirts: "Jeanne shows beneath a feminine visage / Beneath the corset and the petticoat / the vigorous courage of a true Roland."[18] More important than such examples of imitative humor, perhaps, were ensuing images of the Maid inspired out of opposition to Voltaire's satiric epic. Clear outrage against Voltaire's *Maid*, for example, inspired the German poet and playwright Friedrich Schiller to publish his play *Die Jungfrau von Orleans* (The Maid of Orleans). This five-act romantic tragedy expressed, on a grand scale, the playwright's rejection of Voltaire's mock epic and his passionate regard for Joan as a lyrical image of noble beauty. Hailed as a triumph when it opened in Leipzig and

Berlin in 1801, Schiller's romantic tragedy was translated into French within a year by Charles-Frédéric Cramer and Louis Sébastien Mercier. Although Cramer and Mercier's translation of Schiller's play sold poorly (Mercier's preface to the translation earned the ire of French critics by imprudently insisting that German romanticism was superior to contemporary French classicism), the French public's interest in Schiller's play engendered eight new translated editions of the play between 1815 and 1880, and inspired a veritable avalanche of theatrical productions in France during the first half of the nineteenth century.[19] Schiller's vision of the Maid as a courageous woman warrior (fig. 49), torn between duty and

love, ultimately influenced a generation of French artists and authors who produced scores of subsequent literary and artistic celebrations of the Maid's life inspired by the German poet's pathetic and moral "Johanna," who sacrifices everything for her country.[20]

Two years after Schiller's *Die Jungfrau* was first published in French translation, the first public monument to Joan of Arc in over a half century was inaugurated in France (see figs. 36 and 37 above). Edme-Étienne-François Gois *fils*'s *Joan of Arc in Battle* was dedicated in the central place de la République in Orleans on May 8, 1804, a proud embodiment of martial strength and resolve that portrays the Maid lunging forward with her sword drawn and her standard clutched aggressively against her right shoulder. Gois's heroic, over-life-size figure is a modern Minerva, whose steely persona evokes both the Goddess of war chosen by Schiller as the frontispiece to his play in 1801 (see fig. 49), and the last monument to be erected to the Maid's honor under the ancien régime, Paul Ambroise Slodtz's *Joan of Arc as Bellona* from 1755, destoyed in 1944 (fig. 48). In her gown, cuirasse, and feathered hat, with her long hair flying behind, the costume and coiffure of Gois's *Joan* emulates the anachronistic example of the *Aldermen Portrait* (see fig. 30 above), Chapelain's illustrious heroine (see fig. 42 above), and Vignon's heroic Maid for Le Moyne (see fig. 43 above). To contemporaries of the sculpture, however, her costume appeared both accurate and elegant. As one Salon critic wrote in 1802, when the original plaster version of the statue debuted: "One of the advantages of this statue is that the artist was faithful to the features of his heroine. In its costume, it belongs only to its time. Her head is covered by a hat similar to that which she wore."[21] While Gois's plaster sculpture was well received at the Salon in 1802, its good fortune was not made until it caught the eye of one of the most important arbiters of taste in the first years of the nineteenth century—Napoleon Bonaparte, then First Consul

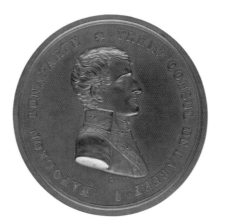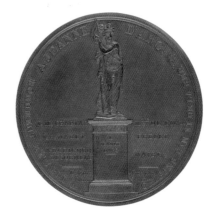

of France. The admiration of Napoleon for Gois's sculpture at the Salon did not escape the notice of onlookers.[22] It was with Napoleon's express interest in Joan of Arc in mind that officials in Orleans sought to launch a fund-raising effort to purchase a bronze cast of Gois's sculpture for use as a monument to the Maid in their city to replace the ancient religious monument to Joan of Arc that had been melted down in 1792. Cognizant that Napoleon's

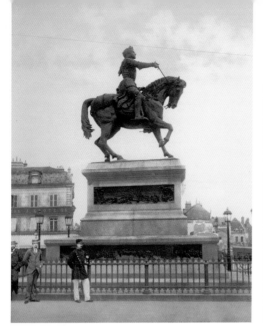

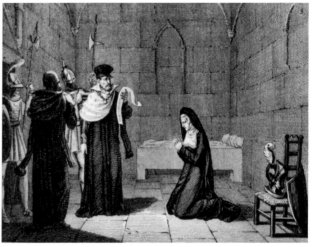

51
Denys Foyatier, *Joan of Arc*, 1855. Bronze. Place du Martroi, Orleans, France. Photochrom, ca. 1890-1900. Library of Congress, Prints & Photographs Division, Photochrom Collection. (LC-DIG-ppmsc-05158)

52
Charles-Abraham Chasselat, *Joan of Arc in the Habit of a Nun Hearing her Death Sentence*, wood-engraving by Louis-François Couché, from P.-A. Le Brun de Charmettes, *History of Joan of Arc*, 4 vols (Paris, 1817): IV, Book XIII.

53
Auguste Vinchon, *King Louis-Philippe and the Royal Family Viewing the Statue of Joan of Arc in the Galleries at Versailles*, 1848. Oil on canvas. Châteaux de Versailles et de Trianon, Versailles, France. (Photo: G. Arnaudet /G. Blot. Photo courtesy Réunion des Musées Nationaux / Art Resource, NY)

approval was necessary for any major local or national project, and painfully aware that public coffers were empty after over a decade of revolution and war, the artist and the Mayor of Orleans devised a plan for raising the money needed for a monumental bronze casting of the sculpture: a public subscription was opened, and a commemorative medal to be given to contributors was struck with the head of the First Consul on one side and Gois's statue on the other (fig. 50). Napoleon's support of the project heralded its success: "The illustrious Joan of Arc proved that there is no miracle that the French genius cannot produce when our national independence is endangered."[23]

Lauded for its accuracy at its inauguration, Gois's sculpture was soon derided for its outdated costume and unfashionable bellicosity after Napoleon's empire collapsed. In 1855, Gois's warrior in a dress and plumed hat was taken down from the central square in Orleans, and in its place was put a new monumental equestrian sculpture by Denys Foyatier of the Maid in full armor lifting her eyes to heaven and dropping her sword in gratitude to God (fig. 51). The call to remove Gois's sculpture, which first began in the 1810s, marked a clear and decisive shift in taste away from venerable but historically inaccurate archetypes towards an increasing concern for the use of accurate and telling historical detail. The growing dissatisfaction with the Maid's martial incarnation also coincided with a revival of adherence to the Catholic faith. With the signing of the Concordat between Napoleon and the Vatican in 1801, Catholicism was tolerated in France for the first time since the

Revolution; during the Bourbon Restoration of 1815-30, it was actively fostered. While Gois's sculpture was criticized for its lack of spiritual expression in the decades that followed the collapse of Napoleon's empire, paintings and sculpture of Joan of Arc as a pious and fervent mystic proliferated. Thus the Maid was portrayed in religious dress kneeling in submissive prayer before her captors in Charles-Abraham Chasselat's wood-engraving *Joan of Arc in the Habit of a Nun Hearing Her Death Sentence* for Philippe-Alexandre Le Brun de Charmettes's important illustrated *Histoire de Jeanne d'Arc: surnommée La Pucelle d'Orléans* (History of Joan of Arc, called the Maid of Orleans) from 1817 (fig. 52). She was also shown fervently praying in prison, with her huge eyes raised as if seeking divine deliverance, before the thundering presence of an enemy prelate in Paul Delaroche's immensely successful canvas *Joan of Arc Interrogated by the Cardinal of Winchester*, exhibited at the Salon of 1824 (see fig. 18 above).

In the hands of the amateur sculptor Marie d'Orléans, the portrayal of a pious Joan of Arc had its apotheosis, as her sculpture of *Joan of Arc in Prayer* (ca. 1834-39) became an astonishingly popular success after a life-size marble version of her work was inaugurated at Versailles in 1837 at the request of her father, King Louis-Philippe (fig. 53). Among the many renditions of this sculpture that were mounted in varying dimensions and materials in churches and public squares throughout France was a life-size cast at the Hôtel de Ville in

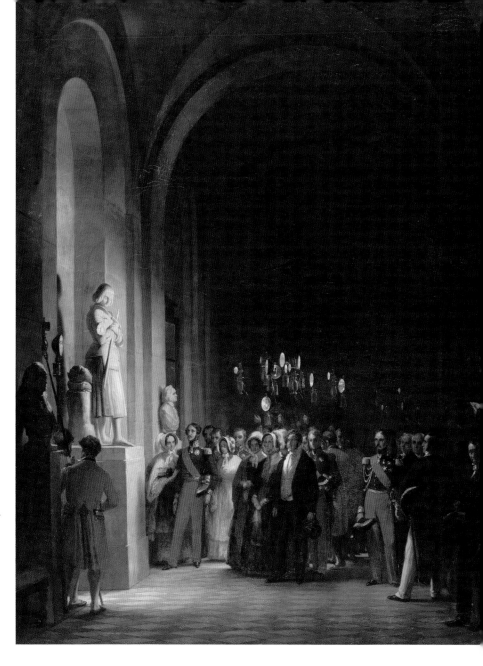

Orleans from about 1837 (fig. 54). After the
princess's premature death in 1839 at the age of
twenty-five, her sculpture's popularity only
increased. In the 1840s, it was produced in minia-
ture as a collectible porcelain by Sèvres, and both
large - and small-scale replicas in plaster, marble,
and bronze were manufactured through the early

twentieth century (fig. 55). The work inspired book
illustrations, popular prints, and commercial
advertisements. It was modeled on coins, carved
on pen and pencil sets, printed on textiles (figs. 56,
57), and copied on vinegar labels. It was even
reproduced in miniature for decorative handbells,
and replicated in silver and gold for a tiny holy
water font (fig. 58). While royal patronage and pop-
ular affection helped to promote Marie d'Orléans's
sculpture, the remarkable popularity of her *Joan of
Arc in Prayer* derived above all from its resonant, if

sentimental, piety (which was highly favored in
the mid-nineteenth century), and from its relative
historic accuracy. The princess's depiction of Joan
with a short, boyish haircut wearing late medieval
armor, complete with elbow guards with shell-like
flanges from the mid-fifteenth century, reflect the
artist's keen interest in medieval history, and her
close familiarity with first-hand descriptions of her
protagonist. Together, they make this work one of
the most historically accurate treatments to date of
the Maid's costume and coiffure.

54
Marie d'Orléans, *Joan of
Arc in Prayer*, ca. 1837.
Bronze. Hôtel Groslot,
Orleans.

55
Marie d'Orléans, *Joan of
Arc in Prayer*, cast after
1843. Bronze. © Dahesh
Museum of Art [2002.16].

56
After Marie d'Orléans,
*Joan of Arc*, ca. 1850. Fabric
printed in France by
engraved and relief rollers
on plain weave cotton.
Cooper-Hewitt, National
Design Museum,
Smithsonian Institution,
New York. Bequest of
Elinor Merrell [1995-50-265].
(Photo: Matt Flynn)

57
After Marie d'Orléans,
*Joan of Arc*, first half of 20th
century. Detail of fabric
probably printed in France
by engraved plate on plain
weave cotton. Cooper-
Hewitt, National Design
Museum, Smithsonian
Institution, New York.
Bequest of Elinor Merrell
[1995-50-266]. (Photo: Matt
Flynn)

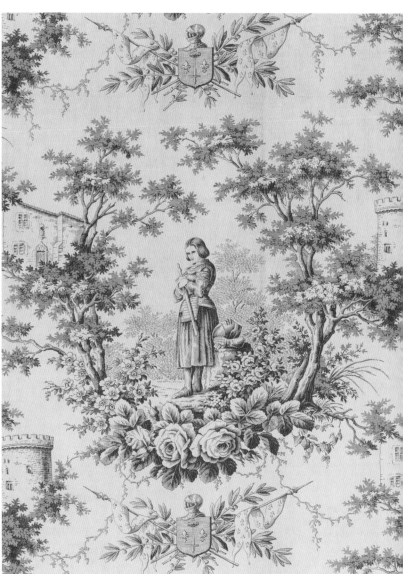

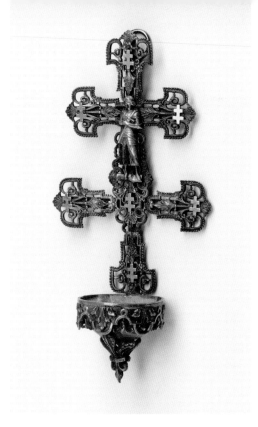

In the most famous images of Joan of Arc produced in the second half of the nineteenth century, these two elements—Joan of Arc's potential to embody spiritual inspiration and the historical accuracy of her portrayal—will remain dominant. Both concerns are central to images of Joan of Arc produced by the pre-eminent academic painter Jean-Auguste-Dominique Ingres. They can be seen in his drawing of Joan of Arc standing beside the altar at Rheims in an elaborate suit of armor with cropped hair, which Ingres completed around 1844 as an illustration for the second edition of Édouard

Mennechet's study of illustrious French men and women, *Le Plutarch français* (The French Plutarch) (1844–47) (fig. 59). In Ingres's illustration, Joan looks towards heaven, with her lips parted as if in prayer. She has the same reverent expression in numerous subsequent drawings that Ingres made of the same subject in preparation for an elaborate painting that he realized in 1854, now in the Louvre (fig. 60). In his painting of the Maid, Ingres sacrifices strict historical accuracy by giving her long hair and intimating a skirt, presumably to make her appear more feminine. Instead, the artist turns his efforts to emphasizing the religious aspects of Joan's portrayal, adding to the scene golden vessels for holding communion wafers, an aspergillum for sprinkling holy water, a smoking censer, a gilded sculpture of the Virgin Mary as Queen of Heaven, even a kneeling and praying tonsured monk. Last, but not least, Ingres traces in gold a thin, radiant nimbus around Joan of Arc's head—the first in any major representation of the Maid.

Jules Bastien-Lepage similarly emphasizes historical detail and transcendent inspiration in his memorable portrayal of *Joan of Arc* listening to her voices from 1879 (see fig. 13 above). Here Joan appears surrounded by saints she cannot see, but whose voices transfix her as she stands in her father's garden. While a halo, the most conventional symbol of sanctity, is not to be found in this image, the Maid's compelling virtue is implied by her unaffected beauty, humble industry (signaled by the hand spinning wheel), and saintly sources of inspiration,

58
Holy water font in the shape of the Cross of Lorraine with miniature *Joan of Arc in Prayer*, after Marie d'Orléans, n.d. Silver and vermeil. Courtesy of the Trustees of the Boston Public Library. (Photo: Dawn Bovasso and Thomas Blake. Boston Public Library)

59
Jean-August-Dominique Ingres, *Joan of Arc*. Burin engraving by Pollet, before 1844, for Édouard Mennechet, *The French Plutarch*, 2nd edn, 4 vols (Paris, 1844–47). (Photo courtesy the Centre Jeanne d'Arc, Orleans)

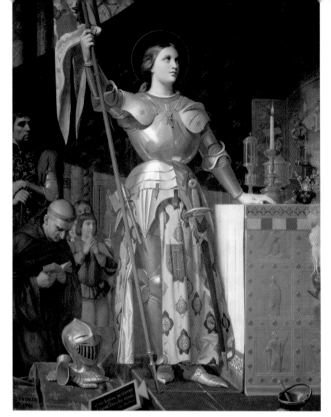

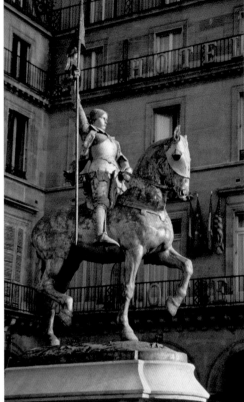

60
Jean-Auguste-Dominique
Ingres, *Joan of Arc at the
Coronation of Charles VII
in the Cathedral of Rheims*,
1854. Oil on canvas. Louvre,
Paris. (Photo Erich Lessing.
Photo courtesy Réunion des
Musées Nationaux / Art
Resource, NY)

61
Emmanuel Frémiet,
*Joan of Arc*, 1872–74
and inaugurated 1875;
replaced by second model
1899. Bronze. Place des
Pyramides, Paris. (Photo:
Vanni / Art Resource, NY)

which float like milky ectoplasm among the trees beside her family's rustic cottage.

In Emmanuel Frémiet's triumphant equestrian *Joan of Arc* (1872–74, partially recast in 1889) in the place des Pyramides in Paris, a halo appears once again, now in the form of a large gilded laurel wreath signaling the Maid's martial success as well as her personal sanctity (fig. 61). Erected in 1874, on the site of the porte Sainte-Honoré where the Maid was wounded in the battle to take Paris in 1429, Frémiet's sculpture was charged from its inception with as much nationalist fervor as religious sentiment. In

the wake of the devastation of the Franco-Prussian War and the Commune of 1870, which scarred both the center of Paris where Frémiet's sculpture stood (fig. 62) and the French psyche, this confluence was perhaps inevitable, since national and religious identity became almost inextricably entangled concerns in the political debate that arose regarding France's future as either a renewed secular republic or a restored Catholic monarchy. Frémiet's *Joan of Arc* played a vital role in providing a site for both partisan celebrations and proxy struggles between competitive political factions, disaffected

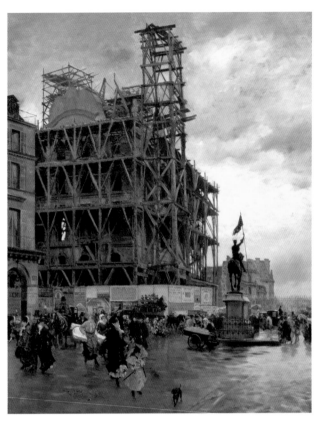

royalists and conservative Catholics on the right and liberal republicans and resurgent anticlericals on the left, in the late nineteenth century.[24] Even today, Frémiet's splendid *Maid* remains pregnant with political controversy and contested memory as the National Front has chosen this monument as the rallying point each May for its ultra-nationalist efforts to restore "France to the French" (fig. 63).

In tracing the many representations of Joan of Arc's image over time, her persona—like Frémiet's sculpture of her—can be seen serving as a resonant source of symbolic meaning. A compelling and multivalent image, this medieval maiden has come to incarnate by turns triumphant royalism and democratic populism, authentic, purifying piety and indomitable martial resolve in the shadow of foreign domination. In assessing the achieve-

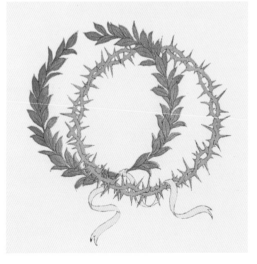

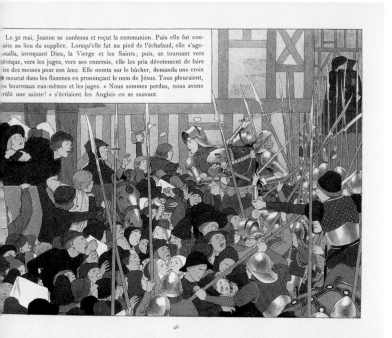

46

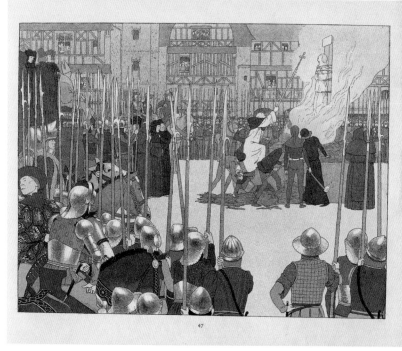

47

ment of Louis-Maurice Boutet de Monvel in describing this remarkable young woman's life, it seems clear that the artist and illustrator's greatest accomplishment was in capturing the complexity and richness of her enduring symbolic potential, at the same time that he celebrated her very real humanity. Thus emblems of sanctity and martyrdom—a laurel wreath and a crown of thorns—emblazon the last page of his life of *Joan of Arc* (fig. 64), while on the title page Joan can be seen leading modern French soldiers to victory under the tricolored flag of the French republic (see fig. 7 above). In between these images, Joan's life unfolds. We see her as a humble and pious girl, frightened at

times but stalwart in her resolve, moved by the sufferings of her wounded enemies but undaunted by her own injuries, as unaffected by popular adula- tion as she was by the intrigues of jealous compatriots. In the end, she remains simple and upright before the insults of captors, suffering, grieving, and ultimately dying with dignity (fig. 65). Poignantly, in the last lines of his introduction, Boutet de Monvel invites the children of France to "open this book with reverence … in honor of the humble girl who is the Patroness of France," insisting that her inspired example may give them courage "in the day when your country shall have need of all your courage."[25]

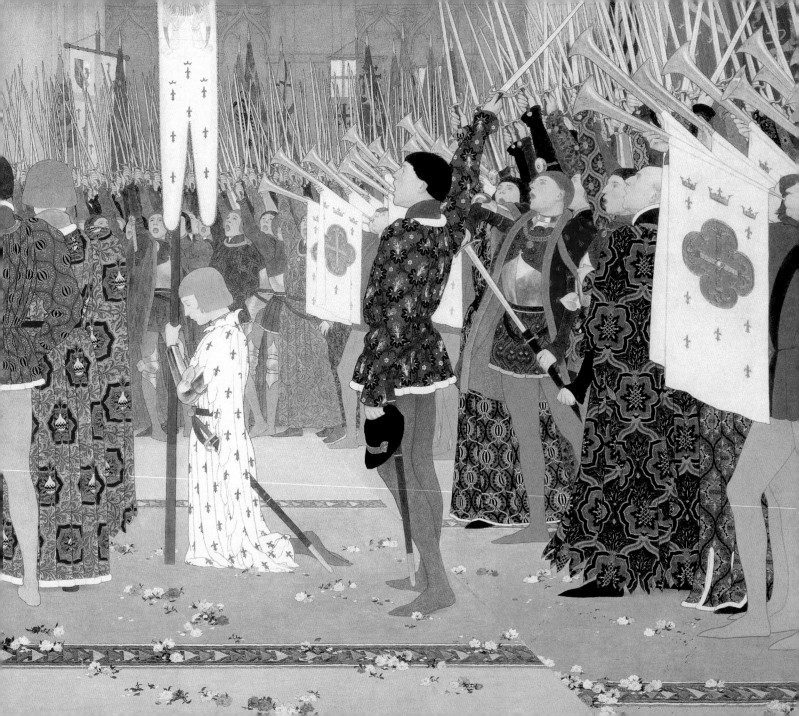

# A UNIVERSAL PATRIOT: JOAN OF ARC IN AMERICA DURING THE GILDED AGE AND THE GREAT WAR

Laura Coyle

*Curator of European Art*

*Corcoran Gallery of Art*

Six dazzling oil and gold leaf paintings (1906–ca. 1912–13) that narrate the life of Joan of Arc, by the French artist Louis-Maurice Boutet de Monvel, inhabit a distinct realm in the Corcoran Gallery of Art's collection (fig. 66; see also figs. 1–6). These alluring paintings arrived at the Corcoran in the 1920s, and enthusiastic critics welcomed them warmly as among the "most heralded works" at the museum as well as "one of the most poetic and inspiring of all the memorials to that mysterious genius and practical visionary—the Maid of Orleans!"[1]

Boutet de Monvel's series radiates with the afterglow of America's passion for Joan of Arc, which lasted from about 1880 to 1918. The cultural context for these works and other famous representations of the Maid circulating during that era illuminates the reasons Americans fell so hard for her: a beguiling combination of Joan's extraordinary patriotism, French nationality, fresh youth, and fair sex. At the same time, the dawning of the American mass media and the expansion of popular entertainment multiplied representations of her and disseminated them far and wide.

William Andrews Clark (1839–1925), one-time senator for Montana (1901–7) and enormously wealthy "Copper King" businessman, commissioned the Corcoran's paintings, but he was just one of Joan's many devotees. From the Gilded Age (1880–1914) through World War I (1914–18), Joan of Arc fascinated legions of Americans young and old, across religious, class, and gender lines. A little digging turns up hundreds of original works of art dating from the 1880s through 1918, as well as plaster casts, reductions, and replicas of famous French sculptures and monuments of the Maid of Orleans, in American schools (fig. 67), museums, and parks. Thousands of books about her written for adults, families, and children crowded the shelves of public and private libraries across the United States (fig. 68), and spellbinding theatrical productions and two Ringling Brothers circus spectaculars featured Joan of Arc's story (fig. 72). Joan also helped to inspire the suffragettes (fig. 70) and to motivate the allied soldiers during the Great War (fig. 71).

In America, Joan of Arc's image as a patriot dates to the nation's founding. In 1798, an Irish

66

Louis-Maurice Boutet du Monvel, *The Crowning at Rheims of the Dauphin* (detail), 1907. Oil and gold leaf on canvas. Corcoran Gallery of Art, Washington, DC. William A. Clark Collection [26.145].

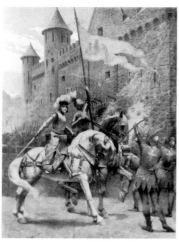
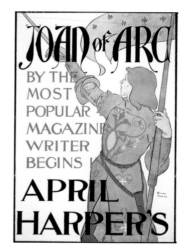
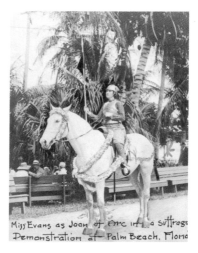

immigrant to the new republic, John Daly Burk, published a short play titled *Female Patriotism: Or, the Death of Joan of Arc*. The new nation and Joan of Arc despised a common enemy—the English—and this shared animosity lent Daly's play a sharp political edge. Over the course of the nineteenth century, however, as American public opinion about Britain and France fluctuated, most Americans simply disconnected Joan of Arc from her historical context. As a result, by the turn of the nineteenth century, when patriotic fervor was running particularly high, the most popular and potent image of Joan of Arc in America was that of a courageous girl or adolescent motivated by a fierce patriotism that transcended any time or place—a universal patriot.

Mark Twain's *Personal Recollections of Joan of Arc by the Sieur Louis de Conte (Her Page and Secretary)* voices this theme consistently and clearly.[2] Few today remember this "historical romance" for adults and children, but Twain insisted that of all the books he had written, it was his favorite. His daughter Suzy, on whom his Joan is partly based, claimed her father loved but two women, "Momma in the present, and Joan retrospectively."[3]

*Harper's New Monthly Magazine* serialized *Personal Recollections* from April 1895 to April 1896 (fig. 69) and published it as a book when the series ended. The story received mixed reviews, loved by some and considered a "gorgeous failure" by others. Several reviewers criticized Twain for his frequent anachronisms in the novel's dialogue. Others objected because the book lacked Twain's signature wry humor, and almost everyone agreed that Twain's Joan was too perfect to be entirely convincing. Nonetheless, the novel features many moments of real power, poignancy, and wit, and it sold well through World War I.

67
A crowd welcomes a plaster cast of *Joan of Arc in Domremy*, 1872, by Henri Chapu, to the State Normal School for Women (now James Madison University) in Harrisonburg, Virginia, ca. 1917. Photograph. James Madison University, Carrier Library Special Collections.

68
F. V. Du Mond, "The Capture of the Tourelles," illustration for Mark Twain, *Personal Recollections of Joan of Arc* (New York: Harper & Brothers, 1896). (Photo: Chan Chao)

The "Translator's Preface" in the novel is purportedly by one Jean François Alden, who claims to have translated the Sieur Louis de Conte's memoir of his childhood with Joan in Domremy and his service to the Maid until "that black day came" and de Conte was "the last she touched in life."[4] The fictional de Conte begins his tale with an assessment of the impassioned patriotism in their village. The love of country that Joan demonstrates throughout her life remains the main theme of the book, which ends with de Conte's stirring, if implausible, oration:

> With Joan of Arc love of country was more than a sentiment—it was a passion. She was the Genius of Patriotism—she was patriotism embodied, concreted, made flesh, and palpable to the touch and visible to the eye.
>
> Love, Mercy, Charity, Fortitude, War, Peace, Poetry, Music—these may be symbolized as any shall prefer: by figures of either sex and of any age; but a slender girl in her first young bloom, with the martyr's crown upon her head, and in her hand the sword that severed her country's bonds—shall not this, and no other, stand for PATRIOTISM through all the ages until time shall end?[5]

This intensely patriotic Joan appears again and again during the late nineteenth century and the early twentieth in dozens of American magazine articles, biographies for adults and children, historical novels, plays, and amusements. For three decades, a secular, patriotic image of Joan

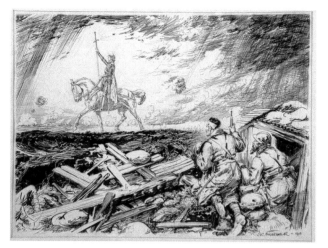

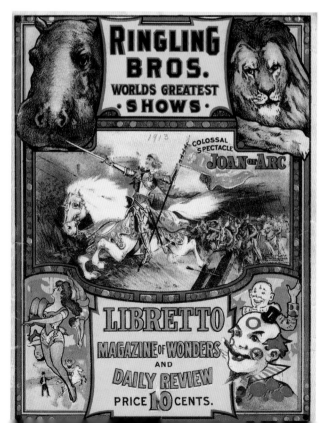

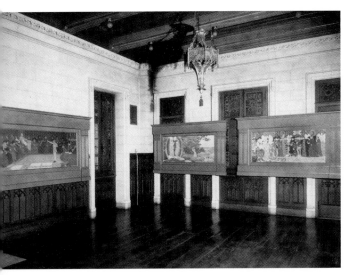

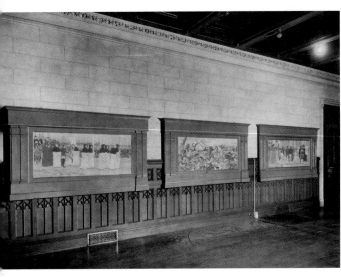

of Arc in America trumped all others and became the basis for interpreting all forms of Joan of Arc representations.

Senator William A. Clark no doubt greatly appreciated Joan's love of country, but his choice of Joan of Arc for his paintings was also bound up with his great love of France.[6] Like many other Americans during the Gilded Age, Clark adored everything French. For his French-style mansion in New York City, "America's costliest palace,"[7] completed in 1912, he intentionally selected a French artist and a French subject for his most important commission. Among the more than one hundred rooms in the mansion was a bastion for male gaming, bonding, and deal-making, a domed Gothic-style Great Hall wainscoted in English oak for smoking and billiards (figs. 73, 74). Along with the six scenes of Joan of Arc's life, the Great Hall featured four early sixteenth-century Loire tapestries and a section of thirteenth-century stained glass originally from a window in Soissons Cathedral.[8] Although decorations based on a young girl's life initially may seem odd for an intensely masculine space, period rooms were much in vogue in Clark's lifetime, and paintings about the famous fifteenth-century heroine who saved France fit perfectly the French medieval theme of this grand recreation room. During the Gilded Age, Clark's eclectic combination of French medieval artifacts and modern paintings in a brand new "Gothic" Great Hall was considered very fashionable.

73 and 74
Smoking and Billiards Room with paintings of Joan of Arc by Louis-Maurice Boutet de Monvel in the residence of William A. Clark, New York, ca. 1925. Photographs. Corcoran Gallery of Art Archives, Washington, DC. (Photo: Chan Chao)

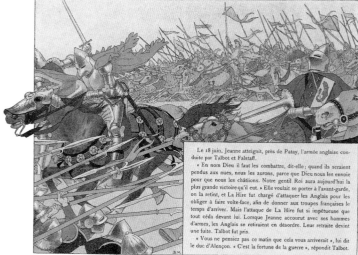

Le 18 juin, Jeanne atteignit, près de Patay, l'armée anglaise con-
duite par Talbot et Falstaff.

« En nom Dieu il faut les combattre, dit-elle ; quand ils seraient
pendus aux nues, nous les aurons, parce que Dieu nous les envoie
pour que nous les châtiions. Notre gentil Roi aura aujourd'hui la
plus grande victoire qu'il eut. » Elle voulait se porter à l'avant-garde,
on la retint, et La Hire fut chargé d'attaquer les Anglais pour les
obliger à faire volte-face, afin de donner aux troupes françaises le
temps d'arriver. Mais l'attaque de La Hire fut si impétueuse que
tout céda devant lui. Lorsque Jeanne accourut avec ses hommes
d'armes, les Anglais se retiraient en désordre. Leur retraite devint
une fuite. Talbot fut pris.

« Vous ne pensiez pas ce matin que cela vous arriverait », lui dit
le duc d'Alençon. « C'est la fortune de la guerre », répondit Talbot.

The paintings that Boutet de Monvel created for Clark are based upon certain pages of the artist's extremely popular French children's book, *Jeanne d'Arc* (1896; figs. 75 and 76). Even before the Century Company in New York City published the American edition of this book in about 1897, Boutet de Monvel boasted a strong following in the United States. The gorgeously illustrated *Joan of Arc* catapulted him to fame. Less than a decade after the book was first published, Clark engaged Boutet de Monvel to paint his decorations, and in so doing, he chose one of the most popular French artists in America.

Senator Clark probably discovered Boutet de Monvel's Joan of Arc picture book soon after it was published in France. At the turn of the century, he resided in Montana and New York City, but in 1901 he settled his French-Canadian wife, Anna Eugenia La Chapelle, in Paris. Although Clark spent long periods in the United States, he often stayed in France. More to the point, Clark and his wife had two girls, Andrée (1902–1919) and Huguette (b. 1906), born in Paris and raised in a French-speaking household.[9] The family had the means and interest to acquire the deluxe edition of *Jeanne d'Arc*—the pages were separate lithographs on expensive paper in a clothbound portfolio tied with a silk ribbon— as well as the trade edition; the little Clark girls almost certainly owned at least one copy of this very popular book, which provided the templates for the Joan of Arc series commissioned by their father.

Boutet de Monvel completed the Joan of Arc paintings for Clark out of sequence. The first

75 and 76
Louis-Maurice Boutet de Monvel, *The Battle of Patay*, two pages from the deluxe edition of his *Jeanne d'Arc*, no. 77 (Paris: E. Plon, Nourrit et Cie, 1896). Corcoran Gallery of Art. Gift of an anonymous donor [2002.14]. (Photo: Chan Chao)

finished, *Her Appeal to the Dauphin* (see fig. 2 above), is dated 1906. The painter dramatized the moment when Joan of Arc meets Charles VII. Despite her slight figure and youth, she captures the attention of the grand courtiers around her, who stare with disbelief at the bold stranger. The following year, he completed the second painting for Clark, *The Crowning at Rheims of the Dauphin* (see fig. 5 above), which celebrates the high-point of Joan's success. The third, *The Vision and Inspiration* (see fig. 1 above), was ready in time for the Paris Salon, the annual state-sponsored exhibition, which opened in 1909 on April 15. Clark very proudly sent his three new Joan of Arc paintings to this high-profile venue.

According to Clark, Ambassador Henry White and others "were loud in their praises" of Boutet de Monvel's "magnificent work." Clark wrote to the Corcoran's director, Frederick B. McGuire, that the paintings "grow in interest with repeated observation." He continued, "I feel confident that the full series of six pictures when all completed and properly hung in my New York residence will create a sensation." The director, as culpable of flattering donors as most museum directors are, wrote back that the press reports showed them to be "the most distinguished works" at the Salon. Clark confirmed that they were "a great triumph for the painter," and "the most visited and highly commended" at this famous exhibition.[10]

Clark also noted in his correspondence that Boutet de Monvel had begun the fourth painting,

*On Horseback, The Maid in Armor* (see fig. 3 above), showing Joan of Arc solemnly setting out from Blois with her army to raise the siege of Orleans. After completing this panel, Boutet de Monvel's health failed significantly. He was about to begin work on the dynamic and complex scene of the battle at Patay, *The Turmoil of Conflict* (see fig. 4 above), when Clark gently persuaded him to work first on *The Trial* (see fig. 6 above). This way, if the painter were able to finish only five paintings, the series would still have a fitting conclusion.[11] It is notable that Boutet de Monvel, no doubt reflecting Clark's preference, closed the series with a defiant and heroic Joan testifying at her trial rather than with the subject featured on the last page in the picture book, a heartbreaking image of Joan on the pyre (see fig. 65 above).

Despite his poor health, Boutet de Monvel managed to complete both *The Trial* and *The Turmoil*. Just before his last three paintings — *The Maid in Armor*, *The Turmoil*, and *The Trial*—debuted at the Salon, however, the artist died on March 16, 1913. Duncan Phillips, the great collector of modern art and future founder of the Phillips Collection in Washington, DC, noted at the Salon that Boutet de Monvel's works possessed "a haunting charm."[12]

Collectors such as Phillips, as well as the general public in the United States, did not question French superiority in the arts, and Americans after the mid-nineteenth century brought home many French representations of Joan of Arc.

The American artist J. Alden Weir, for example, purchased Jules Bastien-Lepage's *Joan of Arc* (1879; see fig. 13 above) for New York collector Erwin Davis. This massive and captivating painting would become and remains the most famous painting of Joan of Arc in America. When it was first exhibited in Paris, some French critics quibbled with Bastien-Lepage's style and strongly objected to the way he chose to represent the Maid's voices. By contrast, in the United States, Bastien-Lepage's Joan, a hauntingly beautiful, barefoot peasant mesmerized by the words of Saint Michael hovering behind her, generated great enthusiasm because of its subject and its Old World origin. Richard Watson Gilder, an art critic for the widely read *Scribner's Monthly*, noted, "The picture is interesting not merely because its moving story is so well told, but because it is a notable instance of the new movement in French art."[13] The painting's visibility only increased after 1889 when Davis donated it to the Metropolitan Museum of Art. In 1924 an anonymous observer for *The Mentor* noted that "the public at large has adopted the canvas as its own. Critics once said the picture was too full of details. To-day [sic] the average observer finds in these very details much to interest [him] and [to] compel admiration."[14]

The controversy sparked in France over Bastien-Lepage's materialization of Joan's voices did not travel to the United States with the painting. Unlike the French, most Americans simply accepted that Joan believed her voices were supernatural, without feeling compelled to believe in, deny, or explain them. In the United States, the question of whether or not Joan was truly guided by God barely impinged on the dominant, secular image of Joan of Arc as a patriot. This relative unity of opinion among Americans about the most important aspects of Joan's story and character contrasts with the contentious division among the French during the same period between those who privileged exclusively conservative religious interpretations and those who favored more liberal secular ones.

In addition to French paintings like Bastien-Lepage's, French sculpture of Joan of Arc also arrived in America. The French community in Philadelphia donated a replica of Emmanuel Frémiet's equestrian sculpture for Fairmount Park in 1890 to celebrate the centenary of French presence in the city. At the festive bilingual dedication, the local Girard College Band played the "Marseillaise."[15] Many smaller bronze versions of Frémiet's triumphant Joan (see fig. 61 above) also entered American private and public collections, as did bronze reductions of the most beloved mid-nineteenth-century sculpture of Joan of Arc in France, Princess Marie d'Orléans's introspective *Joan of Arc in Prayer* (see fig. 55 above). Similarly, bronze and plaster casts of Henri Chapu's placid and pious *Jeanne d'Arc* often resided in colleges (see fig. 67 above) and seminaries. Reproductions of these sculptures, as well as many other

works devoted to Joan, graced the title pages and served as illustrations for dozens of American publications. Photographs of Joan of Arc paintings and sculpture were also disseminated in huge numbers to public schools.

The widespread popularity of works devoted to Joan of Arc in halls of learning was probably due not only to her patriotism but also her exemplary morality. The morals of contemporary French men and especially women, however, was readily questioned by many mid-nineteenth-century Americans, who believed that French men were lazy, French women were loose, and the entire French race was dissipated. Although opinion of the French gradually improved towards the turn of the century, almost all information about their culture was gained second hand. Americans could see French art in the United States, but an inordinate few during the Gilded Age had the means to experience France itself by traveling abroad the way Senator Clark did. While remaining wary of its actual inhabitants, the vast majority of Americans learned about France and its people through texts and images, seduced by a romantic idea of *fin de siècle* Paris.

This enticing if not entirely savory view of Paris made Americans even more curious about the French. It stimulated the demand for serious as well as recreational reading about France, while publishers naturally gravitated to subjects that were becoming or were already popular. The Century Company, which published Boutet de Monvel's *Joan of Arc*, and Harper Brothers & Company, which published Twain's *Personal Recollections*, competed directly with each other and other publishers for a growing audience hungry for articles, stories, illustrations, and books about France in general and about Joan of Arc in particular. With new technology making printing faster and cheaper, readers up and down the economic spectrum were offered a wide range of edifying and entertaining literature. While sometimes targeting men, women, or children, major publishers usually aimed at a larger, general audience of both sexes and all ages. While catering to the American fascination with France, publishers at the same time inevitably molded American readers's opinions about the French.

With his disarming interviews, straightforward writing, and, above all, his charming illustrations in the American press, Boutet de Monvel played a significant role in shaping many Americans' ideas about Joan of Arc and in conveying a more wholesome view of contemporary French society. In addition to *Joan of Arc*, several of his children's books were popular in the United States, including *Good Children and Bad* (1890), a guide to dos and don'ts (fig. 77) and his books of French songs, that taught American children such ditties as "Sur le Pont d'Avignon."[16] His representations of children (fig. 78) became so familiar in America that boys and girls who were "ideally childlike and winsome" were told by amused adults, "You're a regular Boutet!" or referred to affectionately

Paul, ce jeune étourdi dont nous avons déjà parlé, a la manie de s'essuyer le nez en le frottant sur la manche de sa blouse, comme le ferait un petit paysan. Cela dégoûte tout le monde, et quand ses parents s'en aperçoivent, ils le mettent en pénitence. Ils ont bien raison.

Une autre très-mauvaise habitude est celle de ces enfants qui enfoncent continuellement leurs doigts dans leur nez. Gardez-vous de pareille chose, et ne prenez pas exemple sur la vilaine Fanny, qui, par sa malpropreté, fait le désespoir de sa maman.

AS SHE WENT ON HER WAY WITH EVEN STEPS AND LOOKING VERY WISE AND GOOD SHE HEARD A PRETTY SOUND OF BIRDS CRYING BEHIND HER, AND TURNING HER HEAD SHE RECOGNIZED THE LITTLE BEGGARS THAT SHE HAD FED WHEN THEY WERE HUNGRY. THEY HAD BEEN FOLLOWING HER. "GOOD NIGHT, LITTLE FRIENDS," SHE CALLED TO THEM. "GOOD NIGHT. IT'S TIME TO GO TO BED NOW. GOOD NIGHT."

77
Louis-Maurice Boutet de Monvel, illustration from his *Good Children and Bad* (Paris: E. Plon, Nourrit et Cie, 1887). (Photo: Chan Chao)

78
Louis-Maurice Boutet de Monvel, illustration from Anatole France, *Our Children, Scenes from the Country and the Town* (Paris: Librairie Hachette, 1887). (Photo: Chan Chao)

as "My little Boutet."[17] The artist also illustrated articles about French family life such as one by Anna Bowman Dodd. Writing for *Century Magazine* in 1910, Dodd assured Americans that most French mothers were extraordinarily self-sacrificing; they would never be found among the "giddy, frivolous world of the few thousand that live in Paris whose passion for dress, whose inordinate love of display, or whose amorous longings furnish writers and playwrights with their models."[18]

Dodd's efforts to improve opinion of the French capitalized on Americans' fascination with family life and childhood during the Gilded Age. Intense interest in children, child development, and the transition between childhood and adulthood permeated the culture and remains strong today. The focus on family and children in Boutet de Monvel's books and painting—he was highly sought after as a portrait painter of children in France and the United States—only increased his popularity.

The cult surrounding childhood also fed the fascination with Joan of Arc, a remarkable girl on the verge of adulthood. Her youth encouraged many writers on both sides of the Atlantic, including Boutet de Monvel and Twain, to make her the subject of books for children or families.

Although Joan of Arc's youth appears obvious and relevant to her story now, of the hundreds of visual and literary representations of Joan of Arc

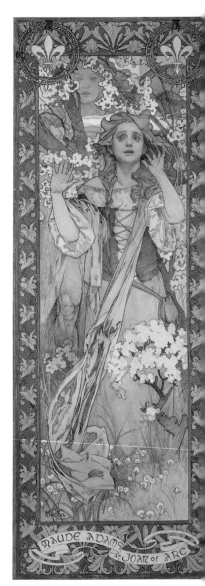

circulating before the mid-nineteenth century, not one represented her accurately as the girl she was when she first heard her voices or the adolescent she was when she died. This situation had changed radically by the end of the nineteenth century, as images of a young Joan, such as Boutet de Monvel's slim, earnest teen and Twain's "marvelous child," a "slender girl in her first young bloom,"[19] multiplied and vied with more traditional representations of her as a mature woman.

Both the youthful and mature Joan of Arc found their places on the stage, as the Maid's burgeoning popularity manifested itself in numerous theatrical events. The most famous actress in America, Maude Adams, played Joan in an English version of Friedrich Schiller's *Die Jungfrau von Orleans* (The Maid of Orleans) in a single performance in Harvard Stadium, on June 22, 1909, to raise money for the new Germanic Museum at Harvard University.[20] Instead of playing Joan as an elegant lady (see fig.41 above), barefoot peasant (see fig. 13 above), or an invincible goddess of war (see fig. 49 above), Adams, who was a little slip of a thing, performed Schiller's Joan of Arc, according to a reporter in the audience, as "a fragile, spiritual maiden sent by heaven to free her country and enthrone her king …"[21] (fig. 79).

Another reviewer commented the day after the production that, "More than 15,000 people sat in the bowl of America's great amphitheatre and gazed in wonder and astonishment as Maude Adams began the triumph of her career when, assisted by a strong company of 1,000 … she produced a new version of *Joan of Arc* in open air."[22] The night of the performance, however, New England's changeable weather had everyone on edge:

The thunderstorm came—came with a rush, just after the great procession, with its thousands … yet no one was in the least incommoded, for it was all done by machine, behind the sky curtain—a whirling barrel of bullets for the rain, a forge blower for the wind, a series of 'broken contacts' for the lightning,

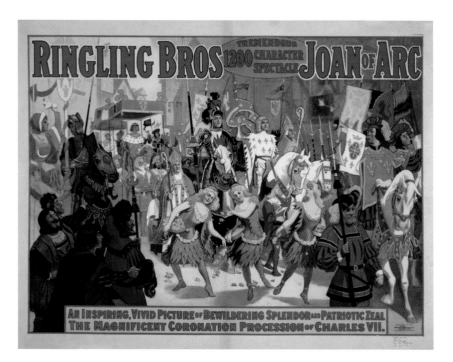

79
Maude Adams as Joan of
Arc in *The Maid of Orleans*
by Friedrich Schiller at
Harvard Stadium, June 22,
1909. Photograph. Private
collection.

80
Alphonse Mucha, *Maude
Adams as Joan of Arc*,
1909. Oil on canvas. The
Metropolitan Museum
of Art, New York. Gift of
A. J. Kobler, 1920 [20.33].
(Photo: © 1982 The
Metropolitan Museum
of Art)

81
*Ringling Bros. Tremendous
1200 Character Spectacle
Joan of Arc*, 1912.
Lithograph. Library
of Congress, Prints &
Photographs Division,
Washington, DC.
(LC-USZC4-5222)

and for the thunder—well, from the very top of the Stadium seats to the ground ran a wooden chute, in sections, with drops in between, and down this cannon-balls were rolled by the supers who played Jove. With crash upon crash, the cannon-balls came down the drops, and the whole result was enough to make any weather man look to his laurels.

It was, the regular correspondent for the popular magazine *The Spectator* concluded, "the event of the season—academic, social, and dramatic."[23]

This elaborate event received enormous press coverage, sending descriptions and photographs of Adams as Joan of Arc across the United States. Adams's remarkable role as Joan of Arc is worthily interpreted by the Art Nouveau master, Alphonse Mucha. His ethereally beautiful, wide-eyed Joan (fig. 80) stands rooted in place, listening intently to the insistent voice of the almost invisible specter of Saint Michael behind her. At Adams's request, the life-size portrait, in its gorgeous gold Art Nouveau frame, hung prominently for over a decade in the lobby of the famous Empire Theatre in New York City. There it was admired by thou-

sands of theater-goers until it was donated in 1920 to the Metropolitan Museum of Art.

While Adams's performance of Schiller was geared toward adults, Joan of Arc also figured in the entertainment for "children of all ages"—the circus—for an unprecedented two seasons, in 1912 and 1913 (fig. 81). During the Gilded Age, circus performances told stories, and these narrative spectacles, or "specs," as they were called, were usually based on fairy tales, myths, bible stories, or historical events. Joan of Arc's remarkable exploits provided the Ringling Brothers with a tempting choice for a spectacle.

One problem with the story of Joan of Arc for the circus, though, was its tragic ending. In 1912 John Ringling wrote enthusiastically to his brother Al about a French circus production with Joan of Arc he had seen at the Hippodrome:

One feature in this spectacle amounted to a

sensation and was the talk of Paris; in the spectacle they burned Joan of Arc, and as the smoke and flames came up around Joan, she made her getaway into the bottom of the funeral pyre, and in her place there was a very finely gotten up dummy, dressed just like Joan of Arc, and two angels came down from the top of the building on wires ... and ascended into the top of the building bearing Joan of Arc.

He concluded, "This could easily be done at the Coliseum in Chicago. " Al nixed the idea, reminding his brother they had agreed already to finish the spec with the triumphant Coronation. John persisted, but Al prevailed (fig. 83).[24]

The poster for the show barks, "Ringling Bros. Joan of Arc, a Tremendous 1200 Character Spectacle, an Inspiring, Vivid Picture of Bewildering Splendor and Patriotic Zeal!" A photograph of the star of the 1912 production shows

that the Ringlings cast their Joan of Arc as a mature woman played by the sturdy Mrs. Bartic (fig. 84). During this golden era for the circus, no other entertainment had such a wide reach. The circus—with hundreds of performers, strutting splendidly in their gorgeous costumes; teams of horses, prancing proudly in their festive tack; the magnificent big-top, ringing loudly with orchestrations of music and pyrotechnics—touched almost every American. Circus promoters maintained that their shows offered all Americans, especially

children, great moral lessons about courage, discipline, and fortitude; but for the most part, millions of Americans enjoyed the circus because it was affordable, accessible, and, above all, fun. Over two summers Ringling Brothers presented the Joan of Arc spec in an astonishing 300 cities and towns, from Altoona, Pennsylvania, to Zanesville, Ohio, all around the United States and into Canada. [25]

The second year of the Joan of Arc circus, 1913, also marked the year of the great march for women's suffrage in Washington, DC, a show of

82
Louis-Maurice Boutet de Monvel, *Attack on the Fortress of Saint-Loup*, study for the double-page illustration from his *Jeanne d'Arc* (Paris, 1896). Watercolor. Memorial Art Gallery of the University of Rochester. Gift of Mr. Simon N. Stein.

83
*Ringling Brothers World's Greatest Shows and the Newly Added $500,000 Spectacle with 1200 People, Joan of Arc*, 1913, advertisement with illustrations based on a double-page illustration by Louis-Maurice Boutet de Monvel from his *Jeanne d'Arc* (Paris, E. Plon et Cie, 1896). Seymour Adelman Fund, Special Collections Department, Bryn Mawr College Library.

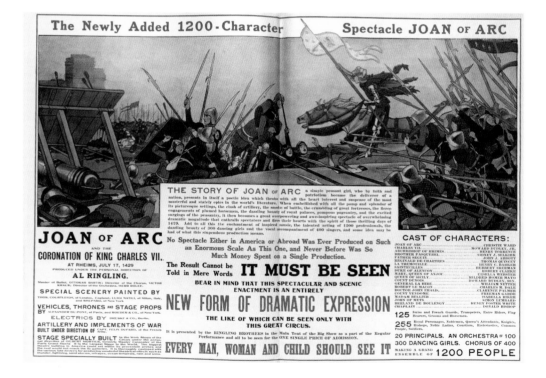

solidarity that encouraged socially and politically active women to make suffrage their first priority (fig. 87). Inez Milholland, a charismatic, socialist lawyer, dressed in white, led the parade astride a white horse (fig. 86). Referred to on the event program and in the press as a "herald," the splendid Milholland, mounted for battle, powerfully evoked Joan of Arc, a heroine who was greatly admired among members of the suffrage movement. For them Joan of Arc represented patriotism, courage, militancy, piety, moral authority, and a

84
*Mrs. Bartic as Joan of Arc in the Ringling Bros. Spectacle.* Photograph by Frederick Whitman Glasier. Collection of the John and Mable Ringling Museum of Art Archives, Sarasota, FL.

85
Marjorie Annan Bryce on horseback dressed as Joan of Arc at the Women's Coronation Procession, London, June 17, 1911. Photograph. Museum of London, London. (Photo: Courtesy HIP / Art Resource, NY)

86
Inez Milholland as Joan of Arc in the Woman Suffrage Procession, Washington, DC, March 3, 1913. Photograph. Library of Congress, Prints & Photographs Division, George Grantham Bain Collection, Washington, DC. (LC-DIG-ggbain-11374)

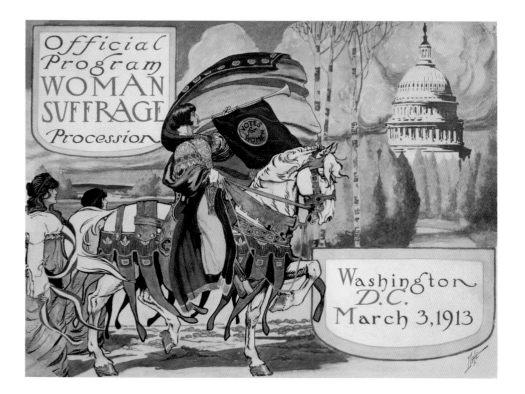

87
Official Program for
the Woman Suffrage
Procession, Washington,
DC, March 3, 1913.
Lithograph. Library
of Congress, Prints &
Photographs Division,
Washington, DC.
(LC-USZC4-2996)

fighting spirit, but it was her sex and challenge to gender roles that made her particularly relevant. The organizers of the march, Alice Paul and Lucy Burns of the Congressional Committee of the National American Women Suffrage Association, had recently participated with Milholland in Emmeline Pankhurst's militant suffrage movement in Great Britain. Processions in England were often led by women on horseback dressed as Joan of Arc (fig. 85), which no doubt inspired Milholland's costume in Washington.

The suffragettes persistently challenged gender roles, most obviously and publicly in events like parades for women's voting rights; but radical crusaders for the vote were not the only ones questioning women's place in society at the turn of the century. Prevailing social codes at the time regarding female behavior prevented most middle- and upper-class women from participating in public life even as the expanding economy and improving education for women potentially increased opportunities for female employment outside the home.

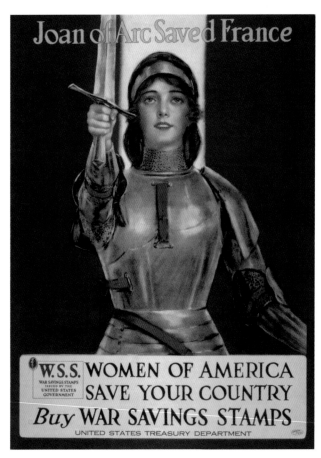

Joan of Arc Saved France

**W.S.S.** WAR SAVINGS STAMPS ISSUED BY THE UNITED STATES GOVERNMENT **WOMEN OF AMERICA SAVE YOUR COUNTRY** *Buy* **WAR SAVINGS STAMPS**
UNITED STATES TREASURY DEPARTMENT

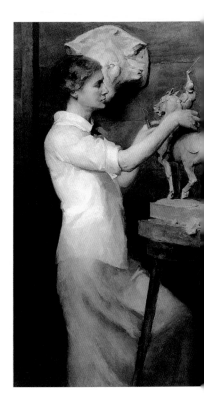

The example of a stalwart Joan—who shared many of the traits associated with male heroes, such as leadership, bravery, discipline, steadfastness and, of course, patriotism—became even more timely as the country drew closer to World War I. With the United States's entry in April 1917 into the war, America united with France and Great Britain in an effort, among others, to expel the Germans from French territories. For the Allies, Joan of Arc's crucial role in driving a foreign occupier out of her homeland only made her more appealing.

Many American women joined the war effort at home and abroad, but not everyone who used Joan's image during this era promoted or was ready to accept major changes in gender roles. During World War I, the United States Treasury Department exploited Joan of Arc's patriotic persona and sex appeal in a poster designed by Haskell Coffin, featuring a buxom, sword-brandishing Joan of Arc with a radiant smile (fig. 88). This enduringly popular image tapped wartime fervor, but counted on American women to do their part at home; the legend on the poster reads: "Joan of Arc Saved France. Women of America. Save Your Country. Buy War Savings Stamps."

Despite the courageous service of many American women during the Great War and the wars that followed, impediments to women as soldiers on the battlefield remain. But during World War I artist Anna Vaughn Hyatt (later Anna Hyatt Huntington) broke a professional barrier in her field

Progressive for his time, Twain wrote in 1895 that the conventional separation of sex roles for men and women was not only invalid but also uncivilized.[26] Joan of Arc—possibly the most famous woman in history to leave home, refuse to marry, and take a job—intrigued the large segment of American society reconsidering strict gender roles.

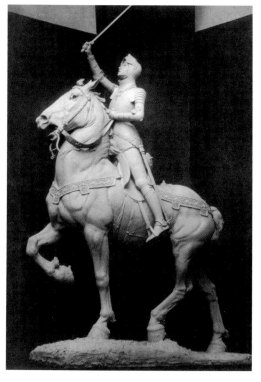

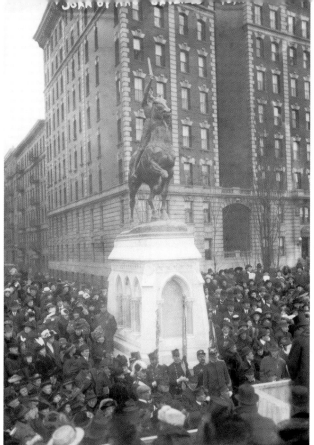

to become the first woman to create a full-scale equestrian monument (figs. 89 and 90), erected in 1915 on Riverside Drive at 93rd Street. Hyatt was commissioned by the Joan of Arc Statue Committee for a Statue in the City of New York—Senator Clark was a member—and when the monument was unveiled, it was hailed in the press as a sign of "the historic friendship between France and the United States."[27] Advised by Bashford Dean, an expert in arms and armor at the Metropolitan Museum of Art, Hyatt strove to make Joan's armor historically accurate. The sculptor also sought to capture Joan's vivacious spirit, religious fervor, and fierce motivation: "I thought of her there before her first battle, speaking to her saints, holding up the ancient sword."[28] George Frederick Kunz, head of the statue committee, dedicated the monument on December 6, 1915 (fig. 91), telling the crowd the monument honored "Joan of Arc, the heroine of the whole world."

Echoing the thoughts of many, Kunz continued, "The memory of her heroic deeds in the past has become a potent animating and encouraging force in the storm and stress of the present dark hour."[29]

Hyatt's monument was used as a gathering place to support soldiers fighting abroad and to celebrate the end of the conflict. Early in the Great War, Joan of Arc had come to stand for the *poilu*, the common French soldier in the trenches. He, like Joan of Arc, was committed to reclaiming stolen territory from the enemy. In the early twentieth century, this meant great swaths of lands on France's eastern front, including Joan's village of Domremy.

The war also inspired a new wave of publications about Joan. These included *The Broken Soldier and the Maid of France* by Henry van Dyke (1919), in which a French deserter finds redemption after a vision of Joan of Arc (fig. 92). Among the many new books for children were Lucy Foster Madison's *Joan of Arc: the Warrior Maid* (1918; fig. 93) and a heavily abridged version of Twain's *Personal Recollections* (1919) that reused pictures, first published fifteen years earlier, by the highly praised and immensely popular illustrator Howard Pyle (fig. 94).

Perhaps bolstered by the wartime literature about Joan of Arc, American soldiers sang a popular patriotic song called "Joan of Arc—Joan of Arc—They Are Calling You" (fig. 95). Thomas Walsh noted in a 1918 article, "The American Army and Joan of Arc," that the dough boys bellowed this tune as "they marched away to their great adventure overseas."[30] For these soldiers as well as the folks back home, Joan stood for all those who had ever fought on the side of liberty, justice, and self-determination. "We find in Joan of Arc," wrote Walsh, "a symbol close to our American hearts and liberty-lovers throughout the world."[31]

Exploiting the connection between the Great War and Joan of Arc, Cecil B. De Mille directed a three-hour-long extravaganza, *Joan the Woman*, starring the glamorous Geraldine Farrar (fig. 97). Produced by Paramount Pictures and described admiringly by the film critic for the New York Times as "among the half-dozen finest films yet produced,"[32] *Joan the Woman* premiered in New York City in 1916 on Christmas Day. The film specifically links Joan of Arc with World War I; for the opening scene, an English Tommy stationed on the French frontier finds an old sword that reminds him of the Maid. That night he dreams vividly about Joan's heroic battles and martyrdom. The next morning, he risks his life in a daring raid on a German encampment. Fighting valiantly, he dies, sacrificing his life selflessly for the cause.

After the war ended in 1918, however, two events dampened enthusiasm for Joan's image,

which until that time had been escalating in popularity. First, within a year after the war, US opinion of France plummeted, a result of the dispute over the repayment of American war loans to the French. In this acrimonious environment, representations of Joan of Arc inevitably reminded Americans of their current feud with their former ally. Americans still greatly admired Joan, but use of her image declined markedly.

The second event that curtailed American representations of Joan of Arc was her canonization. On May 16, 1920, Pope Benedict XV presided over

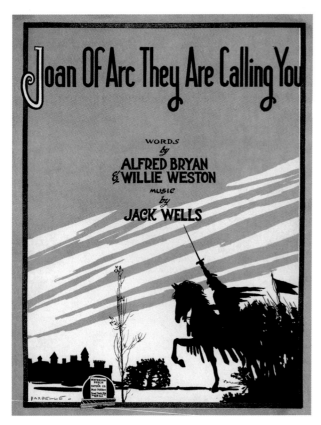

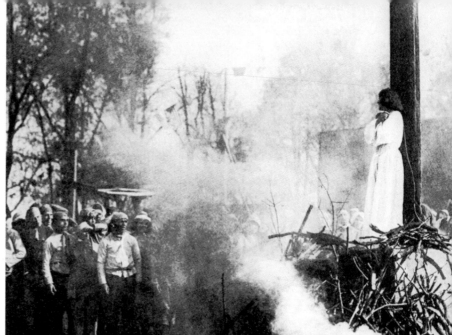

what an American reporter described as "the most impressive function in several centuries" to be held at the Vatican. Celebratory crowds gathered around the United States (fig. 96); twenty-thousand people in the Bronx alone turned out to watch a pageant in eight episodes unfold at Fordham University. The *New York Tribune* reminded Americans that "it was an outstanding fact of our campaign in the Great War that Joan of Arc was almost as much the heroine of the dough-boy as of the *poilu*." The reporter also asserted that because Joan inspired the beginnings of French nationality and gladly gave her life for her country, she has become "the heroine of patriots everywhere. She stands as the saint of patriotism, of nationalism, wherever those words spell sacrifice and devotion to the welfare of one's countrymen."[33]

Nevertheless, the dominant image of Joan of Arc for Americans inexorably shifted after the canonization from a secular to a religious one. Once she became inextricably linked to the Roman Catholic Church, her primary image as a universal patriot gave way to that of a saint and martyr (fig. 98). Furthermore, many of the cre-

ative and popular ways artists, writers, purveyors of entertainment, the government, and politically active groups had capitalized on Joan the patriot now seemed irreverent or incompatible with Joan the saint. With some notable exceptions, in America since the 1920s the Catholic Church has produced or fostered most of the visual and liter-ary representations of Joan of Arc. These images, which naturally emphasize Joan's piety, morality, and sanctity over her patriotism, thrive mainly within Catholic communities.

Between 1880 and 1918, a unique combination of historical, social, and political forces created the conditions for Joan of Arc's enormous following in the United States. During this period images of Joan in America emphasized above all her patriotism, but her patriotic image became more potent when it emphasized at least one of three other attributes: her nationality, her youth, or her sex. The emergence of the mass media and expan-sion of popular entertainment in the United States provided the means to spread widely these inflected images to a highly receptive audience. Placing Boutet de Monvel's Joan of Arc series in its American context, during a time of rapid social change, mounting international strife, and shifting Franco-American relations, allows us to appreciate the tremendous love and following Joan of Arc inspired as a universal patriot in the United States during the Gilded Age and the Great War.

# SOURCES

Archives

Boston, Massachusetts. Boston Public Library, Joan of Arc Collection.

Bryn Mawr, Pennsylvania. Bryn Mawr College Library, Adelaide Brooks Baylis Collection, Special Collections Department.

Cambridge, Massachusetts. Harvard University, Houghton and Widener Libraries, Lowell Collection, Rare Books and Manuscripts, Harvard Theatre Collection.

New York, New York. Columbia University Rare Book & Manuscript Library, Griscom Collection.

Orleans, France. Centre Jeanne d'Arc.

Primary and Secondary Sources

Astell, Ann W., and Bonnie Wheeler, eds. *Joan of Arc and Spirituality*. New York: Palgrave Macmillan, 2003.

Boutet de Monvel, Louis-Maurice. *Jeanne d'Arc*. Paris: E. Plon, Nourrit & Cie, 1896.

—. *Joan of Arc*. New York: The Century Company, 1897.

Fraioli, Deborah A. *Joan of Arc and the Hundred Years War*. Westport, CT: Greenwood Press, 2005.

—. *Joan of Arc: the Early Debate*. Woodbridge, Suffolk, UK; Rochester, NY: Boydell Press, 2000.

—with Earle Havens. *Joan of Arc: Rare Books and Objects of Art from the Cardinal Wright Collection of the Boston Public Library*. Boston: Boston Public Library, 2006.

Goy-Blanquet, Dominique, ed. *Joan of Arc, A Saint for All Reasons: Studies in Myth and Politics*. Aldershot: Ashgate, 2003.

Hansen, Marianne. *Jeannette Jehanne Jeanne Joan: Shepherdess, Soldier, Savior, Saint*. http://www.brynmawr.edu/library/exhibits/jehanne/intro.html. Accessed February 2006.

Heimann, Nora M. "The Art of Politics in Early Nineteenth Century France: E.-É.-F. Gois's *Jeanne d'Arc pendant le combat* as Metaphor," *Gazette des Beaux-Arts* (July–August 1998): 29–46.

Heimann, Nora M. *Joan of Arc in French Art and Culture (1700-1855): From Satire to Sanctity*. Aldershot: Ashgate Publishing, 2005.

*Images de Jeanne d'Arc: Hommage pour le 550e anniversaire de la libération d'Orléans et du sacre*. Paris: Hôtel de la Monnaie, 1979.

*Jeanne d'Arc: Les tableaux de l'histoire, 1820-1920*. Paris: Réunion des musée nationaux, 2003.

Joan of Arc. *Joan of Arc, In Her Own Words*. New York: Turtle Point Books, 1996.

*Joan of Arc Loan Exhibition Catalogue: Paintings, Pictures, Medals, Coins, Statuary, Books, Porcelains, Manuscripts, Curios, etc., published under the auspices of the Joan of Arc Statue Committee (for a statue of Joan of Arc in the City of New York), the Museum of French Art, the French Institute in the United States, and the American Numismatic Society, January 6-February 8, 1913*. New York: Wynkoop, Hallenbeck, Crawford Company, [1913].

Lanéry d'Arc, Pierre. *Le livre d'or de Jeanne d'arc. Bibliographie raisonnée et analytique des ouvrages relatifs à Jeanne d'Arc; catalogue méthodique, descriptif et critique des principales études historique, littéraires et artistiques, consacrées à la Pucelle d'Orléans depuis le xve siécle jusqu'à nos jours; pars Pierre Lanéry d'Arc*. Paris, Librairie Techener, H. Leclerc & Cornuau, successeurs, 1894.

Lightbody, Charles Wayland. *The Judgments of Joan: Joan of Arc; a Study in Cultural History*. Cambridge, MA: Harvard University Press, 1961.

Margolis, Nadia. *Joan of Arc in History, Literature and Film: A Select, Annotated Bibliography*. New York: Garland Publishing, 1990.

*Maurice Boutet de Monvel: Master of French Illustration and Portraiture*. Washington, DC: The Trust for Museum Exhibitions, 1987.

Maurice, Jean, and Daniel Couty, eds. *Images de Jeanne d'Arc: Actes du Colloque de Rouen (25, 26, 27 mai 1999)*. Vol. 1, Collection "Études médiévales." Paris: Presses Universitaires de France, 2000.

Michelet, Jules. *Joan of Arc*. Trans. with an Introduction by Albert Guerard. Ann Arbor: University of Michigan Press, 1957.

Murray, T. Douglas, ed. *Jeanne d'Arc, Maid of Orleans, Deliverer of France; Being the Story of Her Life, Her Achievements, and Her Death, as Attested on Oath and Set Forth in Original Documents*. New York: McClure, Phillips & Co., 1902.

Pernoud, Régine, and Marie-Véronique Clin. *Joan

of Arc: Her Story. Trans. and revised by Jeremy duQuesnay Adams, edited by Bonnie Wheeler. New York: St. Martin's Press, 1999.

Pernoud, Régine. *Joan of Arc: By Herself and her Witnesses.* Trans. from the French by Edward Hyams. New York: Dorset Press, 1988.

—. *The Retrial of Joan of Arc: the Evidence at the Trial for her Rehabilitation, 1450-1456.* Trans. by J. M. Cohen. Foreword by Katherine Anne Porter. New York: Harcourt, Brace, 1955.

Powers, Ann Bleigh. "The Joan of Arc Vogue in America, 1894-1929." *The American Society Legion of Honor Magazine* 49 (1978): 177-92.

Quicherat, Jules Étienne Joseph. *Aperçus nouveaux sur l'histoire de Jeanne d'Arc.* Paris: J. Renouard et cie, 1850.

Quicherat, Jules. *Procès de condamnation et de réhabilitation de Jeanne d'Arc dite La Pucelle. Publiés pour le première fois d'après les manuscrits de la Bibliothèque Nationale, suivis de tous les documents historiques qu'on a pu réunir et accompagnés de notes et d'éclairissements.* 5 vols. Paris: Jules Renouard et Cie, 1841-49.

Terry, Altha Elizabeth. *Jeanne d'Arc in Periodical Literature, 1894-1929.* New York: Publications of the Institute of French Studies, Inc., 1930.

Tisset, Pierre, and Yvonne Lanhers, eds. *Procès de condamnation de Jeanne d'Arc, édité par la Société de l'histoire de France, Fondation du Département des Vosges.* 3 vols. Paris: Librairie C. Klincksieck, 1960-71.

Twain, Mark. *Personal Recollections of Joan of Arc by the Sieur Louis de Conte (Her Secretary and Page) Freely Translated out of the Ancient French into Modern English from the Original Unpublished Manuscript in the National Archives of France by Jean François Alden.* New York: Harper & Brothers, 1896. Reprinted Mineola, NY: Dover Thrift Editions, 2002.

Warner, Marina. *Joan of Arc: The Image of Female Heroism.* New York: Alfred A. Knopf, 1981. Reprinted Berkeley: University of California Press, 1999.

Wheeler, Bonnie, and Charles T. Woods, eds. *Fresh Verdicts on Joan of Arc.* New York: Garland Publishing, Inc., 1996.

Winock, Michel. "Joan of Arc," in Pierre Nora, ed., *Realms of Memory: The Construction of the French Past.* Vol. 3, *Symbols.* Trans. Arthur Goldhammer, ed. Lawrence D. Kritzman. New York: Columbia University Press, 1996: 433-80.

# NOTES

## Joan of Arc: From Medieval Maiden to Modern Saint

1 Boutet de Monvel's *Joan of Arc* enjoyed particular popularity in America in the first decades of the twentieth century. Among the many examples of the book that survive today are editions published by The Century Company, NY, in 1896, 1907, 1908, 1912, 1923, 1926, and 1931; by David McKay, Philadelphia, in 1912 and 1918; by the Grolier Society, NY, in 1967; and by the Pierpont Morgan Library and Viking Press, NY, in 1980. For further discussion of Boutet de Monvel's reception in the America, see Laura Coyle's essay below, "A Universal Patriot: Joan of Arc in America during the Gilded Age and the Great War."

2 The exact date of Joan of Arc's birth is not known. At the beginning of her trial on February 1431, Joan testified that she was "about nineteen years old" (Tisset and Lanhers, ed., *Procès de condamnation de Jeanne d'Arc*, 1:41).

3 Quicherat, *Procès de condamnation et de réhabilitation*, 3:204.

4 Pernoud, *Joan of Arc: By Herself*, 276. We know more about Joan of Arc than we do about many medieval kings and queens—including what she ate, how she dressed, how she wore her hair, even what her private confessor and fellow villagers thought of her.

5 Christine de Pizan, "The Miracle of Joan of Arc," 348-63, trans. Thelma S. Fenster, *The Writings of Christine de Pizan*, ed. Charity Cannon Willard (New York: Persea Books, 1994), 348, 350.

6 Pizan, 356-59.

7 Le Franc's lines devoted to the Maid (stanzas 2102-33 in book 4 of his *Le Champion des dames*) are reproduced in Fraioli, *Joan of Arc: The Early Debate*, 213-17.

8 Translation by John J. Heimann and the author, in consultation with François Michaud-Fréjaville, "Person vs. Personage: Joan of Arc in Seventeenth-Century France," in Goy-Blanquet, ed., *Joan of Arc, A Saint for All Reasons*: 45.

9 The distinctive representation of the Maid in the *Aldermen Portrait* shares with Cranach's *Judith* (especially the versions in Paris, Vienna, and New York) the same anachronistic clothing, most notably a lavishly feathered toque modeled on the popular plumed chapeau worn by men throughout Europe in the first half of the sixteenth century, and an embroidered corset dress with slashed sleeves. "Slashings," first employed by Swiss soldiers in the late 1470s, did not become pervasively fashionable in Europe until the early sixteenth century (R. Turner Wilcox, *The Mode in Costume* [New York: Charles Scribner's Sons, 1958], 77, 86). The *Aldermen Portrait* borrows not only Judith's gesture in holding aloft her sword, but also her act of clutching an object in her left hand. While the handkerchef she holds appears to be merely decorative in the *Aldermen Portrait*, it may have served to replace the gory details of the severed head in the right foreground of the painting's prototype. Even Joan of Arc's anomalous gaudy jewelry—her massive gold chain necklace in the *Aldermen* image—appears borrowed from Cranach's biblical heroine. I am indebted to Olivier Bouzy for this observation.

10 After this bronze monument was damaged by Calvinist iconoclasts, the statue was reconstructed, the figure of Joan was re-founded, and the figures of Christ on the cross and the Virgin Mary standing in prayer were replaced with a pietà. When the pier upon which the monument was situated threatened to give way in 1747, the now aging sculpture was disassembled; it was reconstructed in 1771 on the rue Royale. In its third and last state, the monument was given a new pedestal designed by Robert Soyer. In 1792, it was melted down to make cannons for the war effort (*Images de Jeanne d'Arc*, 27; Pierre Marot, "De la réhabilitation à la glorification de Jeanne d'Arc," in *Mémorial de Jeanne d'Arc, 1456-1956*, ed. Joseph Foret [Paris, 1959], 88; Charles Aufrère-Duvernay, *Notice historique et critique sur les monuments érigés à Orléans en l'honneur de Jeanne d'Arc* [Orleans, 1855], 21).

11 See, for example, Kristin Lohse Belkin and Fiona Healy, *A House of Art: Rubens as Collector*, exh. cat. (Antwerp: Rubenshuis & Rubenianum, 2004), 140-42; for a contrary interpretation of this painting as an autograph Rubens, see W. R. Valentiner, "Joan of Arc by Rubens," *The North Carolina Museum of Art Bulletin* I (Autumn 1957), 11-16.

12 This drawing (formerly in the Museum Narodowe, Warsaw, and now believed to be in a private collection) is reproduced in Justus Müller Hofstede, "Beiträge zum zeichnerischen Werk von Rubens," *Wallraf-Richartz-Jahrbuch, Westdeutsches Jahrbuch für Kunstgeschichte* XXVII (Cologne, 1965), 301, no. 11.

13 Jeffrey M. Muller, *Rubens: The Artist as Collector* (Princeton: Princeton University Press, 1989), 123, pl. 57; *P.P. Rubens: Paints - Oilsketches - Drawings*, exh. cat., edited by Frans Baudouin (Antwerp: Royal Museum of Art, 1977), 46.

14 C[harles] P[aul] Landon, *Annales du Musée et de l'École Moderne des Beaux-arts: Salon de 1819*, vol. 2 (Paris: Imprimerie Royale, 1820), 36.

15 For a complete translation of the Latin in Heince and Bignon's print, see *Images de Jeanne d'Arc*, 47, no. 32.

16 Pierre Le Moyne, *La gallerie des femmes fortes* (Paris: Antoine de Sommaville, 1647) was published in English translation eight years later as Pierre Le Moyne, *The Gallery of Heroick Women*, trans. John Paulet Winchester (London: printed by R. Norton for H. Seile, 1652).

17 Don Apuleius Risorius, bénédictin [Voltaire], *La Pucelle d'Orléans: poëme divisé en vingt chants, avec des notes* (Geneva: Cramer, 1762), 16.

18 *Images de Jeanne d'Arc*, 61-62, no. 62.

19 By one estimation, more than seventy French plays on Joan of Arc from the nineteenth century were imitations of Schiller (Raknem, *Joan of Arc*, 123).

20 Schiller's tragedy inspired Giuseppe Verdi's *Giovanna d'Arco* (1845), Jules Barbier's *Jeanne d'Arc* (1873), Peter Ilyich Tchaikovsky's *Orleanskaya deva* (1878-79), as well as hundreds of lesser-known theatrical imitations in Europe and America. One of the remarkable progeny to be born from these romantic and operatic productions was the Ringling Brothers' *Joan of Arc Colossal Spectacle*. For more on Schiller's *Die Jungfrau*, and its reception in France, see Nora M. Heimann, *Joan of Arc in French Art and Culture (1700-1855)*, 44-72. For further discussion of Schiller's play in America, and the circus productions it inspired, see Laura Coyle's essay below.

21 Alphonse Leroy *fils*, "Sculpture: Aux Rédacteurs du *Journal des Arts*," *Journals des arts, des sciences et de littérature* 232 (20 Vendémiaire an II [12 September 1802]), 112.

22 Léonce Dupont, *Les Trois statues de Jeanne d'Arc, ou notices sur les monuments élevés à Orléans en l'honneur de Jeanne d'Arc* (Orleans: Chez Pesty and Chez Dentu, 1855), 42-43.

23 "Projet," *Le Moniteur Universel* (17 February 1803): 569.

24 For further discussion, see Neil McWilliam, "Conflicting Manifestations: Parisian Commemoration of Joan of Arc and Etienne Dolet in the Early Third Republic," *French Historical Society* 27 (Spring 2004): 381-418; Michel Winock, "Joan of Arc," in *Realms of Memory: The Construction of the French Past*. Vol. 3: *Symbols*, ed. Pierre Nora, trans. Arthur Goldhammer (New York: Columbia University Press, 1996): 432-80; Gerd Krumeich, *Jeanne d'Arc à travers l'histoire*, trans. Josie Mély, Marie-Hélène Pateau, Lisette Rosenfeld (Paris: Editions Albin Michel SA, 1993); Robert Gildea, *The Past in French History* (New Haven: Yale University Press, 1994), 154-65; Albert Boime, *Hollow Icons: The Politics of Sculpture in 19th-Century France* (Kent, OH: The Kent State University Press, 1987), 88-102.

25 Louis-Maurice Boutet de Monvel, *Jeanne d'Arc* (Paris: E. Plon, Nourrit et Cie, 1896), 4.

A Universal Patriot: Joan of Arc in America during the Gilded Age and the Great War

1 Anonymous, "Clark Gallery Includes Many Masters," *New York Herald/New York Tribune* (April 7, 1925): page not known; Agnes Kendrick Gray, "Jeanne d'Arc after Five Hundred Years," *American Magazine of Art* 22 (May 1931): 374. Please note that references have been kept to a minimum for this publication. References for additional sources are available upon request.

2 Mark Twain, *Personal Recollections of Joan of Arc by the Sieur Louis de Conte (Her Page and Secretary) Freely Translated out of the Ancient French into Modern English from the Original Unpublished Manuscript in the National Archives of France by Jean François Alden* (Mineola, New York, Dover Thrift Editions, 2002; originally published New York, Harper & Brothers, 1896).

3 Cited in Yvonne A. Amar, "Mark Twain's Joan of Arc: An 'Asbestos' Character Rising from the Ashes," *Mark Twain Journal* (1978-79): 14.

4 Twain, *Personal Recollections of Joan of Arc*, 2002: xv.

5 Ibid., 318.

6 André Baeyens, *Le Sénateur qui aimait la France, L'aventure de William Andrew Clark* (Paris, Éditions Scali, 2005).

7 Anonymous, "The Astonishing Story and First Photographs of America's Costliest Palace," *New York World* (September 24, 1905): 6-7.

8 Dare Hartwell, "Turning Copper into Gold: The William A. Clark Collection," in Laura Coyle and Dare Hartwell, *Antiquities to Impressionism, The William A. Clark Collection, Corcoran Gallery of Art*

(London, Corcoran Gallery of Art in association with Scala Publishers, 2001): 17-18

9  Baeyens, *Le Sénateur qui aimait la France*: 135-36, 181.

10  William A. Clark to Frederick B. McGuire, March 29, 1909, and April 30, 1909; McGuire to Clark, April 19, 1909, Director's Correspondence, Corcoran Gallery of Art Archives.

11  Clark to McGuire, April 30, 1909, Director's Correspondence, Corcoran Gallery of Art Archives.

12  Duncan Phillips, Personal journal AA, 1913, The Phillips Collection Archives, Washington, DC.

13  Richard Watson Gilder, "Bastien Lepage," *Scribner's Monthly* 22 (June 1880): 233.

14  Anonymous, *The Mentor* 12 (October 1924): 49.

15  Penny Balkin Bach, *Public Art in Philadelphia* (Philadelphia: Temple University Press, 1992): 68, 207.

16  *Good Children and Bad, A Book for Both* (New York: Cassell Publishing Company, 1890); *Vieilles chansons pour les petits enfants* (Paris: E. Plon, Nourrit et Cie, 1883); *Chansons de France pour les petits Français* (Paris: E. Plon, Nourrit et Cie, Paris, 1884).

17  Anonymous, "Boutet de Monvel," *The Outlook* 109 (March 29, 1913): 698.

18  Anna Bowman Dodd, "The Education of French Children," *Century Magazine* 81 (December 1910): 196.

19  Twain, *Personal Recollections of Joan of Arc*, 2002: 2, 318.

20  Horatio S. White, "The Germanic Museum," *Reports of the President and Treasurer of Harvard University, 1908-1909* (Cambridge, MA: Harvard University, 1909): 285.

21  E. F. Edgett in a letter to the *New York Evening Post*, cited in *Literary Digest* 39 (July 3, 1909): 23.

22  Anonymous, June 23, 1909, unidentified review on www.bookmice.net, accessed February 2006.

23  Anonymous, "The Spectator," *Outlook* 92 (July 10, 1909): 590.

24  John Ringling to Al Ringling, January 27, 1912; Al Ringling to John Ringling, February 1, 1912; John Ringling to Al Ringling, not dated; letter copies courtesy of Circus World, Baraboo, WI.

25  "Ringling Routes 1884-1918," *Route Book for 1946* (Sarasota, FL, Ringling Brothers and Barnum & Bailey Circus, 1946): 54-55.

26  Amar, "Mark Twain's Joan of Arc": 18.

27  Anonymous, "Jeanne d'Arc," *The Outlook* 3 (December 15, 1915): 886.

28  Quoted in Michelle Marder Kamhi, "Anna Hyatt Huntington's 'Joan of Arc,'" *Aristos* 4 (March 1988): 4.

29  George Frederick Kunz, "Dedication Address," *Twenty-first Annual Report of the American Scenic and Historic Preservation Society* (Albany, NY: J. B. Lyon Company, Printers, 1916): 515-18.

30  Thomas Walsh, "The American Army and Joan of Arc," *The Bookman* (October 1918): 209.

31  Ibid.

32  Anonymous, "Spectacular Films for Holiday Week," *New York Times* (December 25, 1916): 7.

33  *New York Tribune* quoted in *Literary Digest* 65 (June 5, 1920): 47.

Note: I want to express my profound thanks to Jacquelyn Days Serwer, Chief Curator at the Corcoran Gallery of Art, for her generous support of this project. She is a boss in a million. Nora M. Heimann, my friend and collaborator, deserves much credit and my gratitude as well for teaching me with such enthusiasm and patience about Joan of Arc. I also want to thank Marianne Hansen for her swift and valuable comments on a draft of this essay. L.C.

# INDEX

Joan of Arc
Her Image in France and America

Nora M. Heimann
Laura Coyle

General Editors: Laura Coyle and Nora
Heimann
Editorial Director: Dan Giles
Production Director: Sarah McLaughlin
Designer: Anikst Design Limited
Copy-editor: David Rose
Printed and bound in China

Library of Congress Cataloguing-in-
Publication Data is available upon
request.
ISBN 0-88675-078-4 (soft cover)
ISBN 1-904832-19-9 (hard cover)

The Corcoran Gallery of Art thanks the
Katherine Dulin Folger Publication Fund,
the Samuel H. Kress Foundation, and
The Andrew W. Mellon Research and
Publications Fund for their support of this
publication. The related exhibition, *Joan
of Arc*, on view at the Corcoran Gallery
of Art from November 18, 2006 through
January 21, 2007, is supported by the
Knights of Columbus and anonymous
individual donors.

© Corcoran Gallery of Art 2006

*Joan of Arc: From Medieval Maiden to
Modern Saint*
© Nora M. Heimann 2006

First published in 2006 by the Corcoran
Gallery of Art, Washington, DC, and
D Giles Limited, London

Front cover: Louis-Maurice Boutet de
Monvel, *Attack on the Fortress of Les
Tournelles* (detail), from the deluxe edition
of his *Jeanne d'Arc*, no.77 (Paris, 1896).
Corcoran Gallery of Art, Washington, DC.
Gift of an anonymous donor [2002.14].
(Photo: Chan Chuo)

Back cover: Haskell Coffin, *Joan of Arc
Saved France, Women of America, Save
Your Country*, 1918. Lithograph. Library of
Congress, Prints & Photographs Division.
(LC-USZC4-9551)

Frontispiece: Louis-Maurice Boutet de
Monvel, *Joan before the Dauphin* (detail),
1896. Watercolor. Memorial Art Gallery
of the University of Rochester. Gift of Mr.
Simon N. Stein.